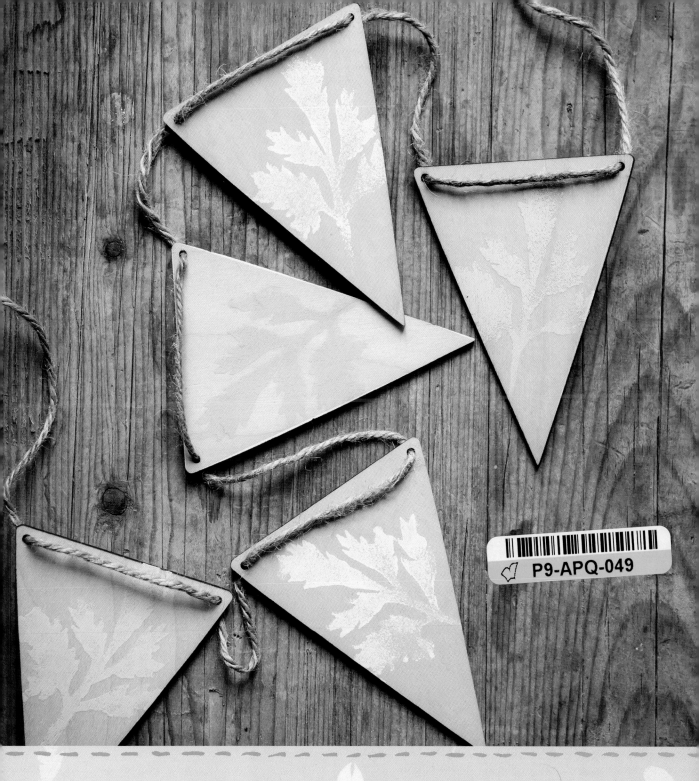

Beginner's Guide to
SCREEN PRINTING

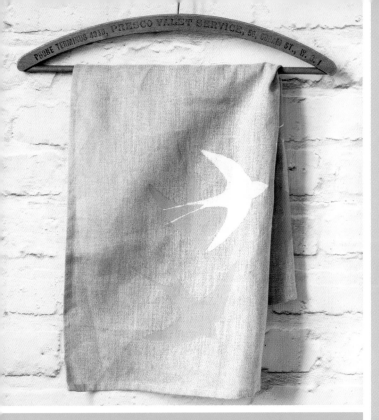

ACKNOWLEDGEMENTS
I would like to thank the following suppliers:
Pick Pretty Paints, Artcuts, Baker Ross,
Hobbycraft, The Clever Baggers, The Natural
Fabric Store and Dinky Screens.

First published in Great Britain 2020
Search Press Limited
Wellwood, North Farm Road,
Tunbridge Wells, Kent TN2 3DR

Text copyright © Erin Lacy 2020
Photographs by Mark Davison for Search Press Studios
except for pages 1–3, 5, 7 (top left, bottom right), 21 (top),
24, 30, 34–35, 37 (bottom right), 42, 46, 58, 63, 71, 73,
80–81, 85, 90, 93 and 98 – photographs by Stacy Grant
Incidental illustrations by Erin Lacy
Photographs and design copyright
© Search Press Ltd. 2020

ISBN: 978-1-78221-724-4

The Publishers and author can accept no responsibility for
any consequences arising from the information, advice or
instructions given in this publication.

Publishers' note
You are invited to visit the author's website at:
www.pickprettypaints.com

Suppliers
If you have difficulty in obtaining any of the materials and
equipment mentioned in this book, then please visit the
Search Press website for details of suppliers:
www.searchpress.com

All the step-by-step photographs in this book feature the
author, Erin Lacy, demonstrating screen printing techniques.
No models have been used.

Beginner's Guide to
SCREEN PRINTING

12 beautiful printing projects with templates

Erin Lacy

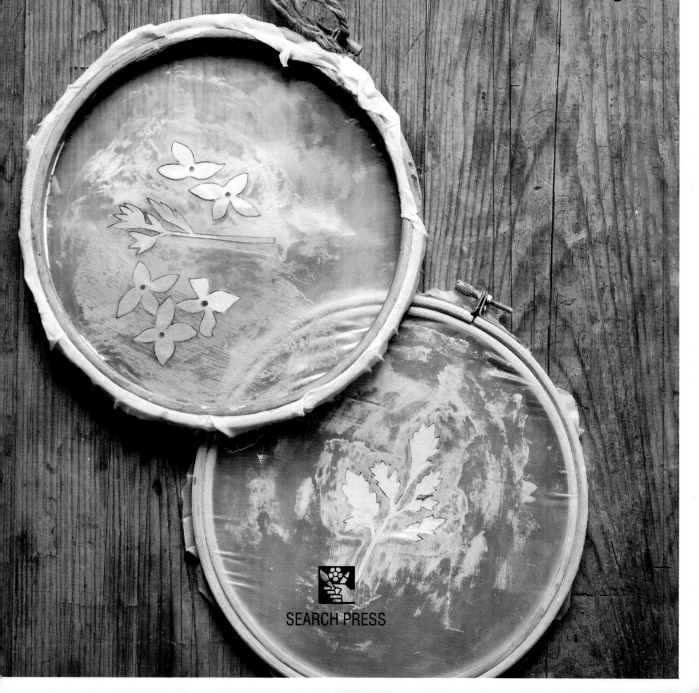

SEARCH PRESS

Contents

The projects

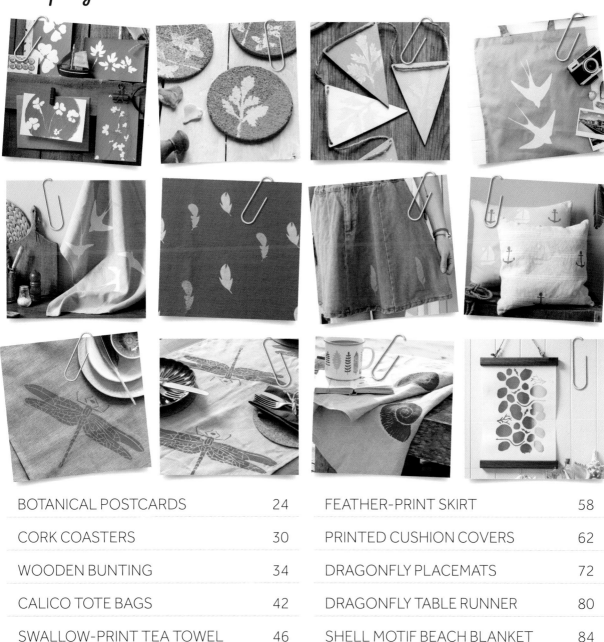

Introduction

Screen printing is a simple and effective way to transform a plain surface. This beginner's guide will take you through the basic steps of screen printing, from adapting a design to transforming it into a print, using many different screen-printing techniques and widely-available equipment.

I print wherever I can, in my studio or out and about. For me, the chance to share my secrets of screen printing is a beautiful gift, and I hope that it will spark a new interest for you on how to transform a surface with print. Being able to develop a piece of artwork from a simple design into a finished, printed item and see results almost instantly is one of the many reasons why I love printing.

I want you to see that screen printing is not just a technique but also a way in which you can explore, and use elements from, the world around you. Many great ideas are inspired by our surroundings so why not incorporate this into screen printing? I live and work in the seaside town of St. Ives in Cornwall, UK, and as a result I integrate nautical and botanical themes into my work.

When working on a printing project, the most challenging task is often the printing itself. The book will provide you with plenty of tips based on what I have found works well for me, and will help you to develop your personal preferences. I will also give you guidance on how to take your screen printing further. Every screen printer works in a different way but I hope that my guide will help you begin your printing journey.

So, please have fun, create some mess and use the techniques and the projects in this book as starting blocks in finding your own screen obsession.

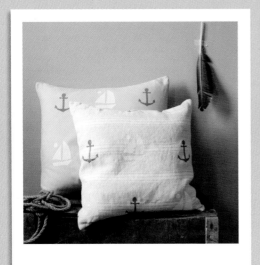

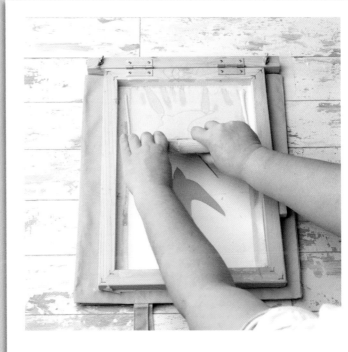

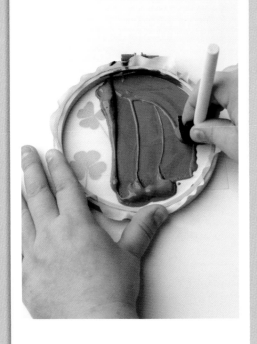

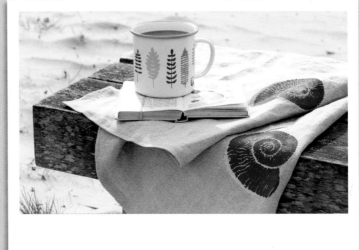

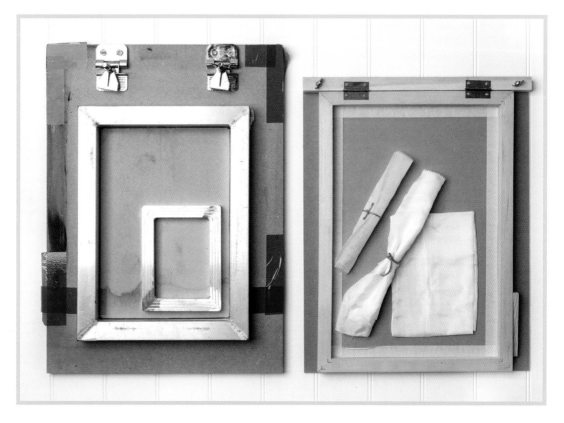

Over the following pages, I explain the roles of the most essential tools and materials you will need for designing, preparing and creating your screen prints. All of these tools can be used in different ways, depending upon the surface on which you wish to print.

For each new technique and project I introduce as you work through the book, I will ensure that you are familiar with the tools and materials needed, and will help you develop your own relationship with the tools that best suit you.

FRAMES

Frames are the structures on which printing screens are mounted; they can be made from a variety of materials. In this book, I show you how to use the metal frames and wooden hinged frames shown in the photograph above, and how to transform an embroidery hoop into a portable printing screen.

Metal frames come in all shapes and sizes; as they are hollow, they are also lightweight and easy to clean down after printing. Their wide, easy-to-grip rims also make them ideal for use when printing onto larger surface areas, such as fabrics that are to be made into cushions, or garments.

Wooden frames typically come as part of a screen printing kit, with the screen already mounted. These also come in different sizes. Both wooden frames and metal frames can be attached to a wooden block base to keep them steady.

Above left, metal frames resting on a wooden block base; above right, a wooden hinged frame attached to a block base; silk and mesh.

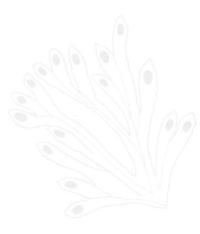

Embroidery hoop frames

Embroidery hoops can be used to make frame screens that you can use either when printing at home or on the go. With the addition of silk or screen mesh, your hoop can be transformed into a useable screen in minutes. As hoops come in a variety of sizes and shapes, you can choose a frame that best suits the size of your design.

If you have a spare embroidery hoop at home, making it into a screen is a great way to upcycle it.

Above, a collection of my embroidery hoop frames.

SCREENS

The role of the screen in the printing process is to transfer paint onto a print surface at an even, smooth consistency. Traditionally, screen printing involved silk as the silk enabled the smooth transferral of the paint onto the surface. This quality is still the main priority in the manufacture of a printing screen.

Silk can be bought by the metre, or in the form of a scarf. Silk comes in a variety of grains and grades – in this book, I use habotai silk when showing you how to make your own screens. Habotai has a very tight grain and the surface is smooth, which makes it ideal for screen printing.

Modern screens are made from a mesh material which can also be bought by the metre, or already mounted on a frame. Mesh can be made from numerous materials – silk, polyester or other manmade fibres. Mesh can also be sold at various mesh count sizes, which impact upon how much paint will get pulled through. Most mesh screens have a standard mesh count of 80–86, which is determined by the number of threads per 1in or 2.5cm.

9

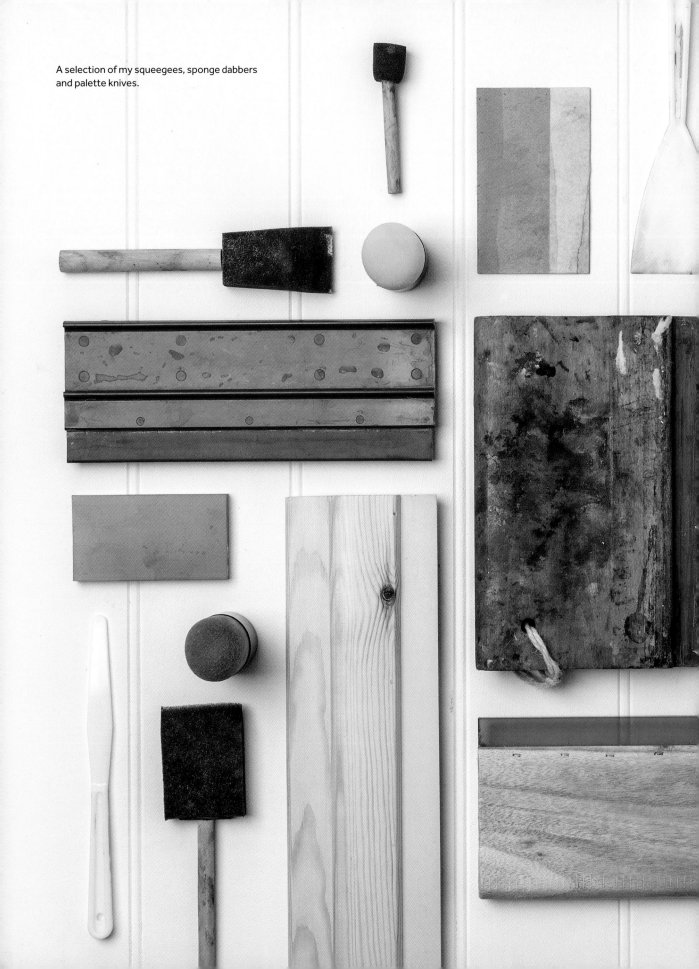

A selection of my squeegees, sponge dabbers and palette knives.

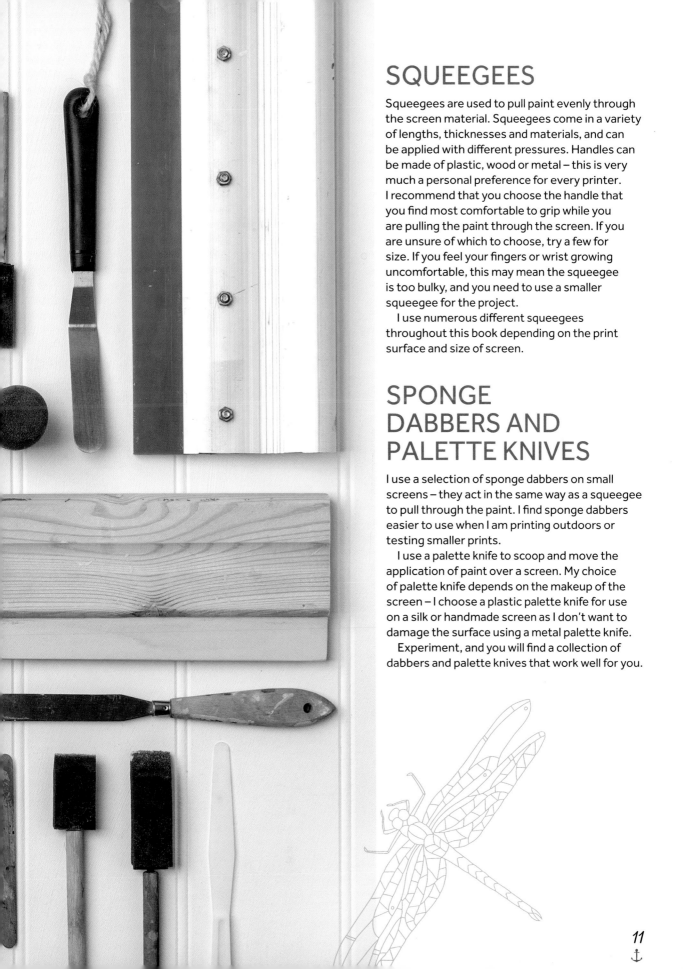

SQUEEGEES

Squeegees are used to pull paint evenly through the screen material. Squeegees come in a variety of lengths, thicknesses and materials, and can be applied with different pressures. Handles can be made of plastic, wood or metal – this is very much a personal preference for every printer. I recommend that you choose the handle that you find most comfortable to grip while you are pulling the paint through the screen. If you are unsure of which to choose, try a few for size. If you feel your fingers or wrist growing uncomfortable, this may mean the squeegee is too bulky, and you need to use a smaller squeegee for the project.

I use numerous different squeegees throughout this book depending on the print surface and size of screen.

SPONGE DABBERS AND PALETTE KNIVES

I use a selection of sponge dabbers on small screens – they act in the same way as a squeegee to pull through the paint. I find sponge dabbers easier to use when I am printing outdoors or testing smaller prints.

I use a palette knife to scoop and move the application of paint over a screen. My choice of palette knife depends on the makeup of the screen – I choose a plastic palette knife for use on a silk or handmade screen as I don't want to damage the surface using a metal palette knife.

Experiment, and you will find a collection of dabbers and palette knives that work well for you.

PRINTING PAINTS AND INKS

There is a wide variety of printing paints and inks available for use in screen printing – printing paints are referred to as inks if they are of a particular consistency. Specialist paints or inks can require a lot of preparation and can involve dangerous chemicals which need to be mixed in specially ventilated facilities.

When printing paints are manufactured, highly concentrated pigments are mixed with various components to make up the paint. The opacity and the strength of the shade of paint will vary depending on the pigment and the blend of ingredients used. This blend can take many years to perfect – if you wish to explore this for yourself, please ensure you seek advice from a working print studio to ensure your paint mixing environment is safe and the properties you wish to use are not harmful. Neon shades, for example, will require strong chemicals and will need to be mixed in well-ventilated areas.

As you are coming to screen printing as a beginner, I highly recommend that you source screen printing paints that are listed as 'ready to use'. Check the ingredients to ensure that they are suitable for home use, and that they can be used on a multitude of surfaces including fabrics. Many of the printing paints and inks on the market can be mixed together to provide you with a wide range of colours like those shown below; this is especially useful when you come to printing gradients (see pages 92–95).

Throughout this book, I use Pick Pretty Paints, which are my own hand-mixed screen-printing paints and inks. These have been produced with a fabric fixer, which ensures that my print creations can be permanently fixed onto any fabric surface. Each shade of paint has been inspired by the Cornish coastline and the surrounding areas. I hope that the colours I use in the screen printing projects in this book will spark your own imagination and encourage you to use a wide variety of colours on different print surfaces.

Larger projects (such as tablecloths or garments) will need larger volumes of paint – check the volume required for each project in the 'You will need' list. Pick Pretty Paints are available in three different tub sizes: 50ml (1.7fl. oz), 100ml (3.5fl.oz) and 250ml (8.7fl.oz). Any paint that you do not use can be decanted back into the tub.

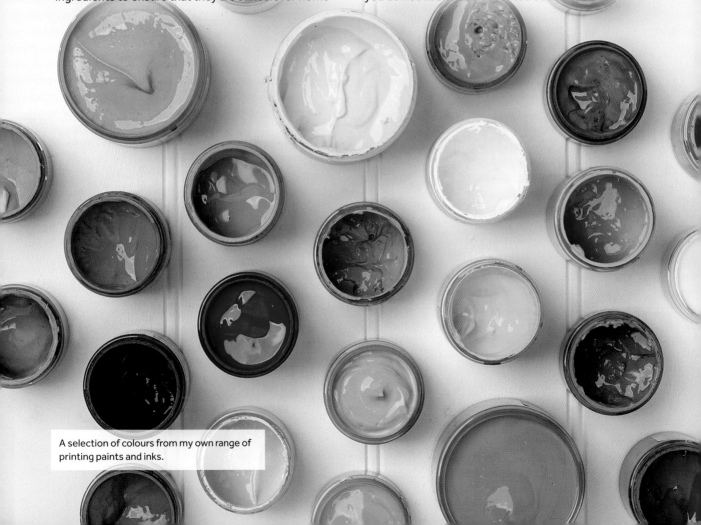

A selection of colours from my own range of printing paints and inks.

STATIONERY AND USEFUL ITEMS

The items below are readily available, and all prove useful when you are learning to screen print.

Ballpoint pen To transfer your designs onto a silk surface without snagging the screen.

Red felt tip pen To make markers on hoop screens for clear guides and reference points (see pages 86–87).

Small and large ruler To use as guides when placing frame screens for repeat patterns and borders.

Pencil To make, transfer and develop templates and stencils throughout the book.

Scissors To cut any excess from your handmade screens and stencil templates.

Teaspoon To decant paint onto your screens.

Rags To wipe away paint and keep the printing area clean; or as a rest for messy tools such as palette knives and squeegees.

Tape measure To use as a guideline for keeping prints straight, to calculate spaces between prints and to calculate fabric shrink percentages (see page 19).

Watercolour paints To paint subjects that can be transformed into stencil designs (see pages 98–101).

Craft knife To cut out stencil designs and details for the screen.

Eraser To remove mistakes on tracings and templates.

Acetate A see-through plastic sheeting used to make stencils (see page 14) and spacers (see pages 65–70); it can also be printed on and used as a marker or template guide for half-drop repeat prints (see pages 50–57).

Mod Podge A heat-resistant varnish which is applied to handmade screens when exposing designs (see pages 28–29). It can be bought in craft shops or through online retailers.

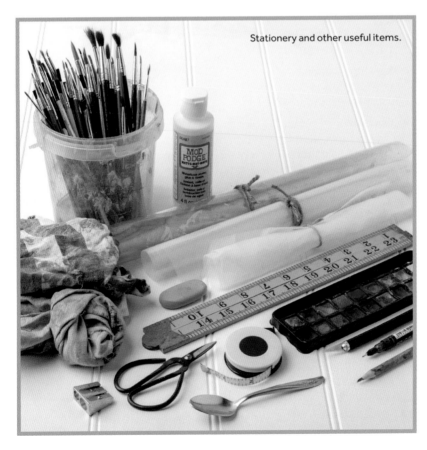

Stationery and other useful items.

OTHER ESSENTIALS (NOT SHOWN)

Wet wipes (baby wipes) Keep these on hand for any printing accidents and for clearing down your worksurface. Printing can be a messy business – wet wipes prevent unwanted paint from being transferred onto your finished print by accident and keep your hands clean throughout the printing process.

Kitchen paper Keep this on hand for quick clean-ups, or to protect your printing tools.

String and pegs To make a temporary washing line for drying printed items.

Apron To keep your clothes clean while you are printing. You can also choose to wear protective gloves.

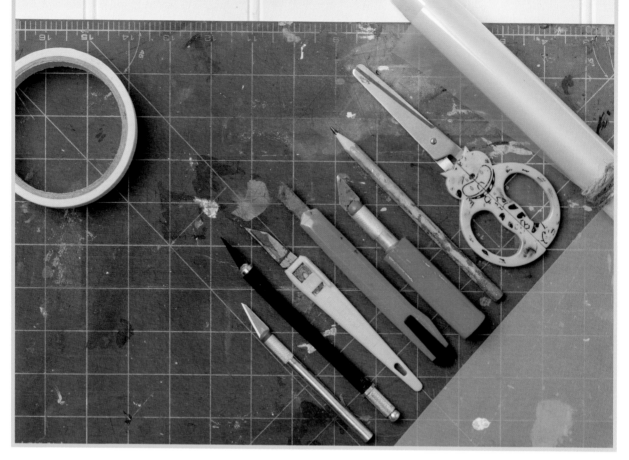

STENCILLING TOOLS AND MATERIALS

Some of my stencilling tools and materials, above.

Stencils for screen printing designs can be made from a number of materials – these are a personal preference and depend on how detailed your design is, or how long you wish the stencil to last on the screen.

Medium-weight card (not shown) This can be used to make a stencil for a one-off design or a short run of designs, such as the swallow print on pages 38–47. Medium-weight cartridge card or gloss-coated card – card with a smooth surface – is better to use.

Sheet of polyester film This is commonly used for making stencils as it is easy to cut. There are several thicknesses of polyester film on the market – try to find a lightweight option. It is a great choice of material if you wish to produce a multilayered design or print a number of prints such as for a pattern repeat.

Contact paper This is a plastic-coated paper with an adhesive side: it is very strong and can be used for stencilling a design onto a larger screen. The adhesion helps prevent your stencil designs from slipping, although once the paper is attached to the screen, you are committed to printing that design. I suggest that you test a small stencil design with contact paper, as the surface is hard to cut.

Acetate This is available in various thicknesses, and is often used, printed, as a marker or as a background stencil for a less detailed design, such as a silhouette. As acetate is see-through, it is ideal for lining up a pattern or layer (see pages 50–57).

Masking tape This comes in a variety of widths and can be used to attach stencils to screens.

Craft knives Keep a selection of these sharp knives to hand to use with different stencil materials. They can be used safely when cutting out detailed stencils.

Scissors To cut out and amend your stencils.

Cutting mat Use a cutting mat as a secure surface on which to cut out your stencil designs with a craft knife. Use an appropriate-size cutting mat for the scale of your design.

PRINT SURFACES

The success of a screen print depends very much on the quality of the surface onto which you print, and the pressure needed to apply the paint. One of the most interesting aspects of screen printing is that the print itself can change, due to any change in that surface.

Screen printing should be applied on a flat, hard base for a smooth, crisp finish. Some studios use a cloth onto which printers pin and secure the fabric they will print onto. This effect can be replicated at home on a smooth tabletop, using a medium-weight tablecloth as a smooth base.

Paper Paper comes in a wide range of finishes, including matt, gloss, handmade, silk and textured. A smooth, heat-pressed cartridge paper is generally the easiest surface to print onto, but I recommend that you try printing sample prints on a selection of papers to find out what print quality you prefer. Some handmade papers with their varied textures can make your resultant screen print more interesting.

Fabric As screen printing is a process in which the paint is pulled through a screen, to sit on top of the surface, it is a good idea to try test-printing on a variety of fabrics ranging from smooth to heavily-textured. Natural or synthetic, tight- or loose-weave fabrics: each fabric will require a certain pressure applied, and a different method of preparation.

See pages 18–20 for guidance on preparing and fixing your fabric.

Textured surfaces – cork and wood Textured surfaces can be tricky to work with but can also challenge your printing technique. Experimenting and working through some of the projects later in this book will give you an idea of how screen printing can also be a pleasing, abstract and contemporary mark-making method when applied to a hard surface such as cork or wood.

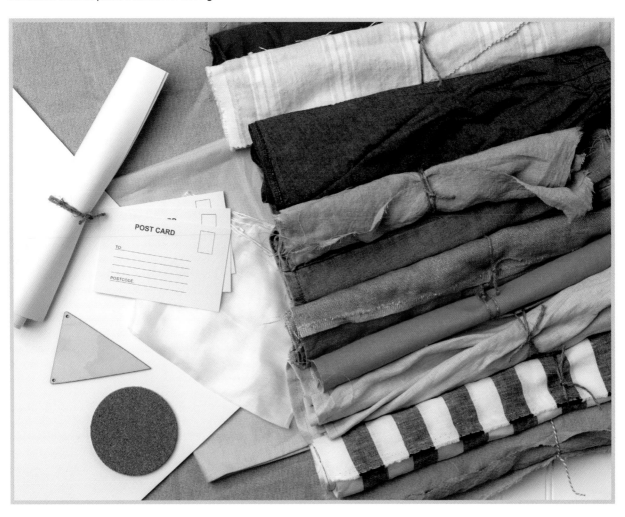

Getting ready to screen print may seem like having to do everything at once, but it does not have to be complicated. These three stages will make the process simple, while also helping you to think about how you should plan your printing time. Many printers space out these stages over several days so don't feel pressured to do all three on the same day.

Personally, I like to incorporate the outdoors in my print processes, as I feel that many printing crafts are restricted by the need for a studio space. However, for the purposes of this beginner's guide, I will introduce you to my preferred methods when printing indoors, and show you how to set up your workspaces so that you are always comfortable and safe, and have everything you need to hand.

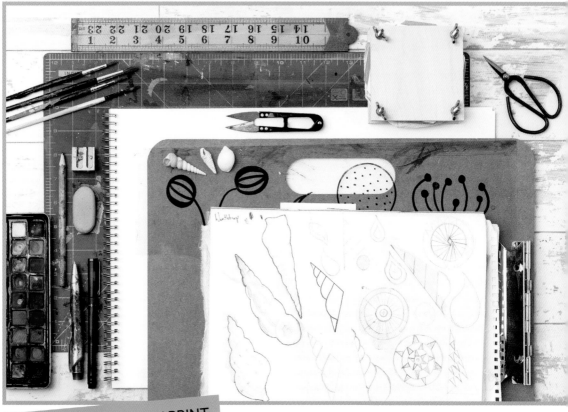

DESIGNING A SCREEN PRINT

The initial design of a screen print can be the longest process at preparation stage. Making sure your artwork is ready to expose or to transform into a stencil can take hours, so I have provided templates for you to use (see pages 102–110) in order to bypass this lengthy stage. If you do want to create your own designs, see pages 96–101 for some ideas.

The creative work space, featuring, clockwise from top left, paintbrushes, cutting mat, ruler, flower press (see page 25), scissors, clipboard, sketchbook, snips, shells, fineliner, ballpoint pen, watercolour paints, pencil, eraser and pencil sharpener.

1 Cutting out a stencil

Cutting out a stencil demands a particular working space. Ensure that you use a suitable cutting surface such as a durable cutting mat and a cutting knife that you have used before and have kept sharp. Keep your work area clear of obstacles or distractions.

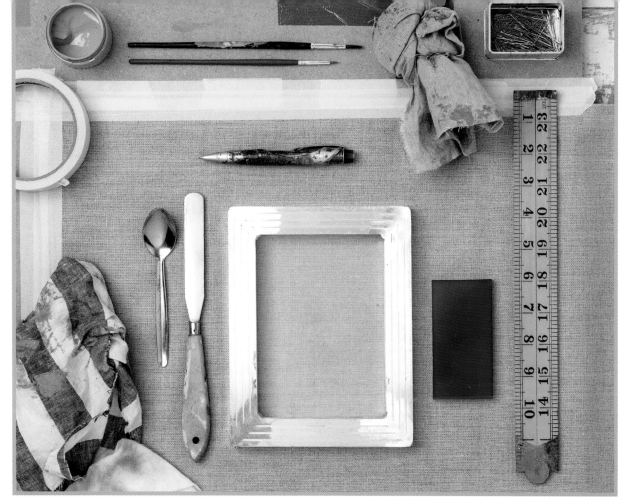

The printing work space, or rest surface, featuring (clockwise from top left) fabric (attached to a flat surface), masking tape, a pot of fabric paint, paintbrushes, rag, safety pins for attaching your print surface to the rest surface, ruler, small plastic squeegee, metal frame screen, metal palette knife, teaspoon, pen and rags.

2 Preparing your printing work space

As important as the print surface is, you should give plenty of consideration to your rest surface – essentially your printing work space. Make sure your rest surface is clean – used tools can easily make the printing space messy, so use old rags to rest your tools on between use.

Screen printing is affected by the surface onto which you print so it is crucial that you make sure that your rest surface is flat and smooth. All printers have different habits, and depending on the limitations of their work space they will adapt by using boards and block bases (see page 40).

Many screen printers stand up to work – this allows them to be mobile at all times, to achieve the right pressure while printing and to move their prints safely to a drying area.

Once you have adapted your workspace to your requirements – sitting or standing – you can lay out your printing tools and equipment. Make sure you give yourself plenty of space in which to place things down and pick them up, to prevent any further paint being transferred from surface to surface.

If you are planning to switch between different print surfaces or items, you will need to allow space in which to mark out your print areas – rest assured, however, I will explain these processes in more detail as you work through the book.

Keep in mind that your work space also needs to include an area in which your prints can dry. Whether this area is a drying rack, a washing line or a clean table, prints need space and time in which to dry naturally, ready for fixing (see page 20).

3 Preparing a fabric print surface

Preparing a fabric surface for printing can take a considerable amount of time if you are not familiar with the traits of the fabric that you want to print onto. Most printers keep a swatch sample book (see below), which you can make yourself – this is a great resource for referencing the effects of print on different textures, logging what has worked well and working out what you may need to change next time you print.

Once you have chosen your fabric, there are still a few things you need to check before you begin to print. Most of the fabric-based projects in this book involve natural linens and cottons. This is mainly because many natural fibres have less chance of shrinkage or discolouration, and are more durable than synthetic fibres. Bear in mind that if you are using screen-printing inks and paints that contain fabric fixers, the printed fabrics will require steaming and washing to fix the print, so be mindful of your fabric choices as some fabrics may shrink during the fixing process (see pages 19–20 for more information).

Before any printing can take place, it is recommended that you pre-wash your fabric to even out any pre-dyed areas and smooth out any loose fibres to give you a flat print surface. If you are printing on ready-made items – such as tea towels or items of clothing – these may have been pre-washed, but do check with the supplier of the items before applying paint.

My fabric sample book (left) and printed fabric samples used for reference on printing on a variety of surfaces.

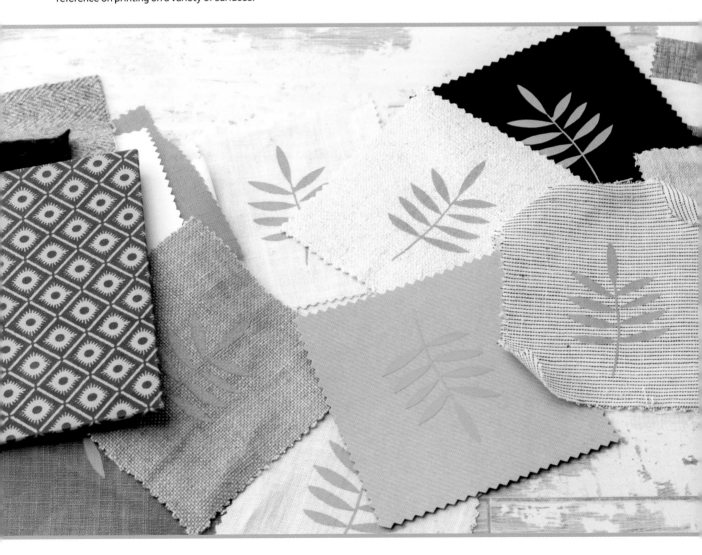

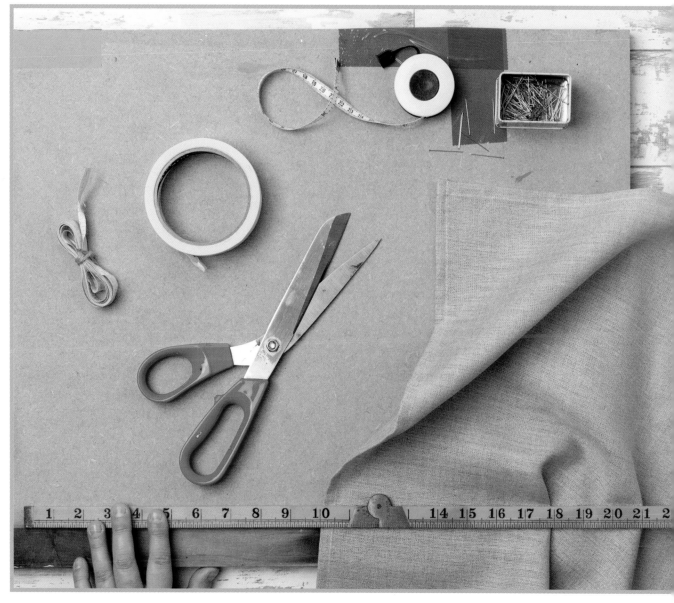

Shrink percentage

Measure your fabric before and after washing to calculate its shrink percentage.

Most fabrics will have a shrink percentage – this can be worked out by measuring your fabric before it is washed (see above) and again after it has been washed. The difference in the size will give you the shrink percentage. This will help you make allowances for any further shrinkage during the fixing process (see overleaf), if you wish to make your printed fabric into something else – a cushion cover, for example.

You can use a simple formula to help you calculate the shrink percentage of any piece of fabric, regardless of the size and fibre grain. Shrinkage may vary depending on whether the fabric is stretchy, or has a larger grain.

Using the formula below, you can work out the shrink percentage for fabric of any size: *Length before washing minus length after washing; Divide by 100 = shrink percentage.*

FIXING YOUR FABRICS

To fix the paint permanently onto fabric, make sure your printed surface is completely dry. You can use either of two methods to fix your design: an iron for smaller, specific printed areas, and a steamer for larger printed areas.

These two processes both work to apply heat to the printed area. This will activate the fabric binder in the paint to react to, and permeate, the fibres of the fabric surface.

Ironing

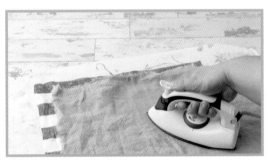

1 Place your printed item on the ironing board. Turn your iron on to a medium heat – use a steam setting if your iron has one, as this will greatly benefit the fixing process. Use an old tea towel or piece of fabric between your printed item and the iron face.

2 Press and hold down the iron for a few moments on each area of your screen print to get an even heat coverage over the print. Two to three minutes should be plenty of time to fix the print, ready to be machine-washed if you wish.

Steaming

Use a vegetable steamer to fix your print as this will provide a consistent source of heat to your fabric surface. Do make sure that you use a steamer that you will use afterwards only for printing, not for steaming food!

Prepare the fabric by folding it or wrapping it tightly with twine to fit inside the steamer (place the fabric inside while the steamer is switched off, to ensure that it fits). Once the steamer has filled up with steam, leave the fabric in the steamer for fifteen to twenty-five minutes, depending on how much fabric you have put in.

After that time, switch off the steamer but leave the fabric inside until the steamer has cooled down enough to allow you to lift out your fabric safely.

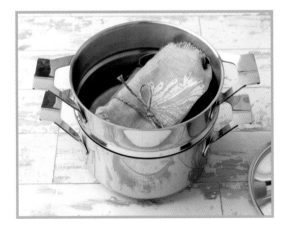

Finally, iron your fabric to press out any creases. If you wish to machine-wash your fabric, it is now ready for you to do so.

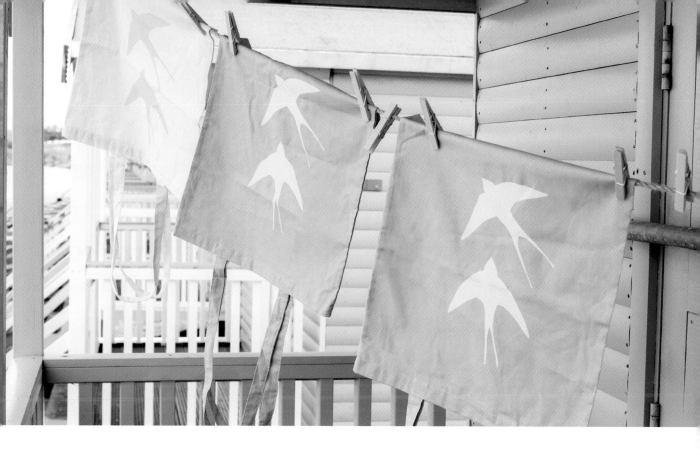

CLEAR-DOWN AND DRYING

Keeping your printing area clean throughout the screen printing process and especially as you finish a print run will help you to preserve your screens for reuse. I always keep a pack of wet wipes (baby wipes) or a handy rag next to my printing area as accidents do happen.

Once you have printed any items, make sure you allow them to dry, out of the way of any printing that is still happening. Ideally, hang printed fabrics outdoors on a washing line (see above); if the weather is unfavourable, you can dry your prints indoors, near a free-standing heater.

Wash down your work area each time you complete a print run. Washing your screens out correctly can help speed up the screen printing process next time. Most of the projects in this book have been designed so that you can wash out your screen in a regular kitchen sink or washing-up bowl (see right). Use soft sponges and warm soapy water to wipe down your screens to prevent any damage to the screen surface. Leaving your screen to soak for five minutes before you wash it will help with the removal of stubborn stencils and masking tape.

Warning

Do not be tempted to speed up the drying process of a clean screen by applying extreme heat to it. Mesh screens in particular can be damaged if dried with a hair dryer, for example – the heat can burn holes in the mesh surface.

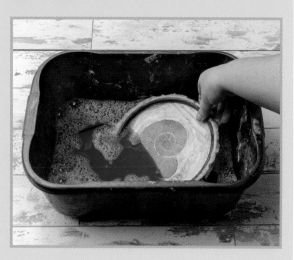

I became interested in making screen printing more mobile when I first moved to Cornwall. I found that using an embroidery hoop gave me the opportunity to teach people the basic steps involved in making a screen at home. Mesh and silk are placed inside the hoop and cut to size – this is a quick and instant way to learn how to make your own screen and to understand exactly why you need a smooth, tight surface to pull paint through.

Embroidery hoops are easy to come by and are great for practising screen printing if you are a beginner. The relatively small size and lightweight nature of the hoop screen are what make it mobile; as a result I have spent many afternoons collecting botanical and coastal finds from the shoreline that I can print through the hoop.

I suggest that you start with a smaller embroidery hoop – 12.7cm (5in) is ideal. The larger the hoop, the harder it is to control.

Make your first silk screen using an embroidery hoop and a habotai silk scarf. You can then use your hoop to print postcards using your own natural, found items in the first project on pages 24–27.

You will need:

⚓ Habotai silk or silk scarf

⚓ 12.7cm (5in) bamboo embroidery hoop

⚓ Fabric scissors

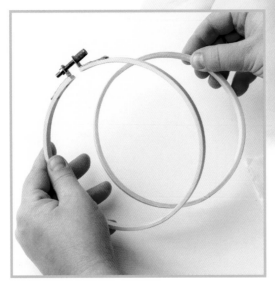

1 Untwist or unscrew your embroidery hoop.

2 Lay your silk scarf in between the two components of the hoop. This will give you an idea of the size of silk you will need in order to cover your screen.

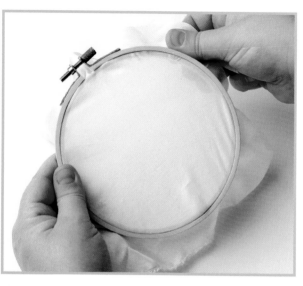

3 Rescrew your embroidery hoop. Cut the silk to a square panel around the hoop.

4 Pull the fabric taut around the hoop until the surface is smooth and tight like a drum head – make sure there are no lumps and bumps.

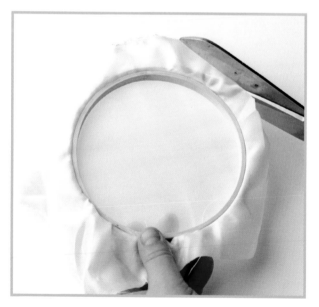

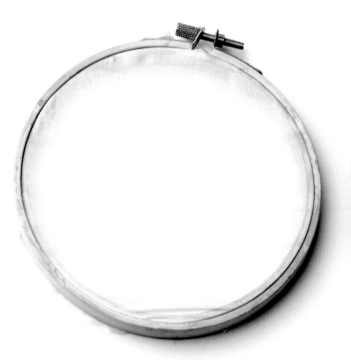

5 When the silk is taut and secure, cut away the excess silk around the hoop, leaving a seam allowance of 1–2cm (⅜–¾in) to allow for any movement of the silk in the hoop, and to avoid too much transferral of paint onto the silk.

You are now ready to use your embroidery hoop as a printing screen.

The embroidery hoop frame, ready to be used.

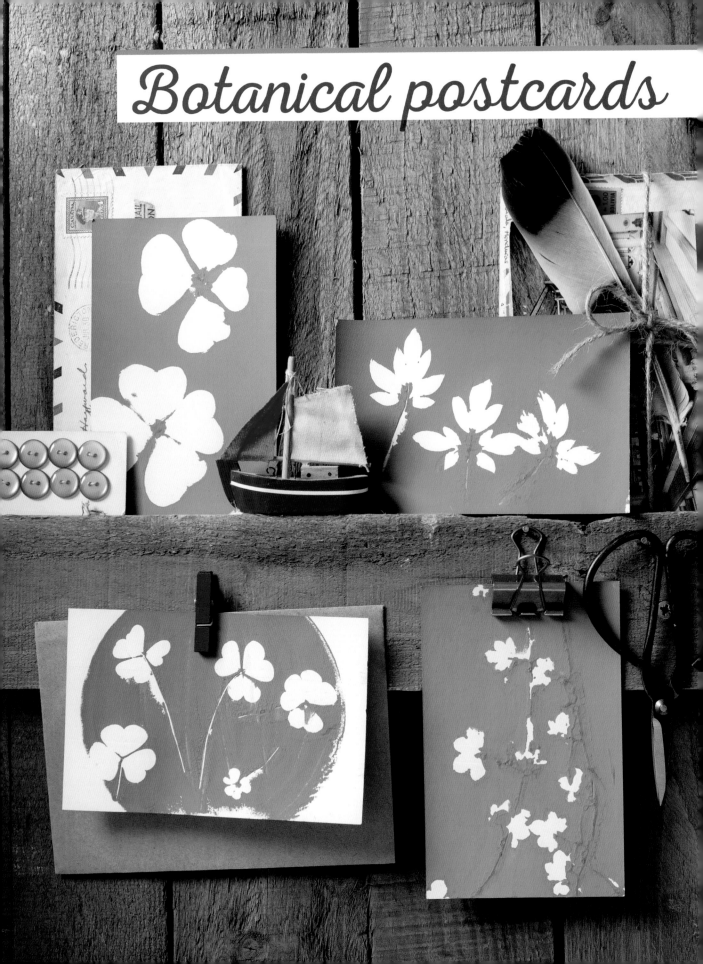

Botanical postcards

Now you have a ready-to-use screen, you can use found botanicals to create unique postcards using a very simple printing technique. The interesting thing about this technique is that you can print any item underneath the hoop if it is flat enough, and has a defined outline as you are effectively printing a silhouette.

Build up a collection of natural, found objects – press these flat, or preserve them in a flower press until you are ready to use them in your printing projects.

I find that printing silhouettes is a good starting point for beginners to screen printing as you do not need to worry too much about the consistent outcome of a design. Each print is a surprise, and printing botanicals will result in fun, abstract outcomes – every postcard will be slightly different.

Blank postcards tend to come in packs, so the more postcards you have, the more test prints you can do. Concentrate on using this project to get used to using the hoop as a screen, and to the pressure you need to apply, as well as the paint-pulling techniques involved in working with a handmade screen.

Why not take advantage of how portable the embroidery hoop is? This is a great project to try while sitting outdoors at a garden table.

You will need:

- ⚓ Found botanicals such as flowers, seaweed or small leaves, ideally kept flat
- ⚓ Scrap paper
- ⚓ 12.7cm (5in) bamboo embroidery hoop mounted with habotai silk scarf (see pages 22–23)
- ⚓ Teaspoon

- ⚓ 100ml (3.5fl.oz) green fabric paint – I have used Cactus shade (Pick Pretty Paints)
- ⚓ Sponge dabber
- ⚓ Wet wipes
- ⚓ Selection of plain postcards – the cards I have used are 15 x 10cm (6 x 4in)

OPPOSITE, PRINTED BOTANICAL POSTCARDS.

Once you are confident in this printing pocess, you can try making a series of art pieces – frame a selection of your botanical prints and transform the postcards into contemporary wall art – what a lovely way to keep a memory! In the past I have also used this process to create beautiful keepsake art pieces for friends using pressed flowers from their wedding bouquets.

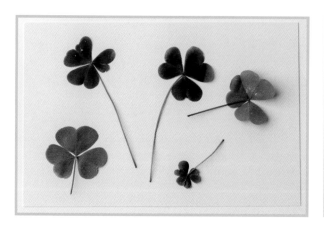

1 Place a postcard down onto scrap paper, on a flat surface. Make sure the botanicals are laid down as flat as possible.

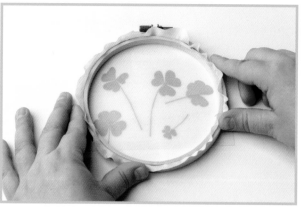

2 Lay your embroidery hoop over the botanicals with a firm grip.

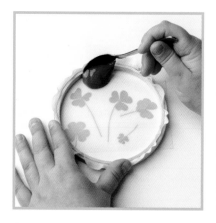

3 Apply a small amount of paint with a teaspoon at the top of the hoop.

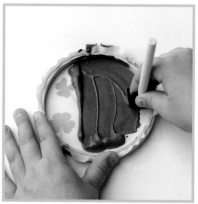

4 Use a sponge dabber to pull the paint down the screen surface. Keep the sponge end at a 45-degree angle to the silk, and apply light to medium pressure as you pull.

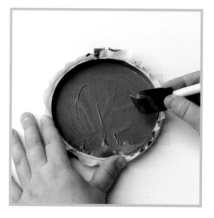

5 Fill the whole surface area of the silk inside the hoop.

Tip

As you grow in confidence you can pull the paint in any direction over the screen – this project is a chance to get used to pulling paint over the surface. Apply different pressures and see how this affects your prints. You may find that a certain application of pressure may flood your design and bleed around the edges, or conversely, help you pick up on small details.

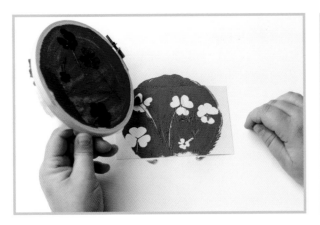

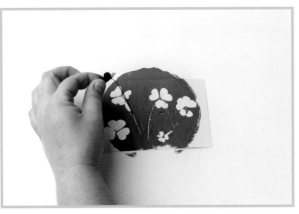

6 This is when the print process could become messy! When you have covered the surface with paint, lift the hoop from bottom to top to reveal your design. You may find that your postcard has become stuck to the screen. If this happens, peel the postcard away at the corners first, to prevent further mess.

7 Remove any foliage carefully from the postcard to reveal the silhouettes of your foliage.

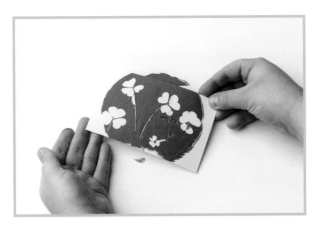

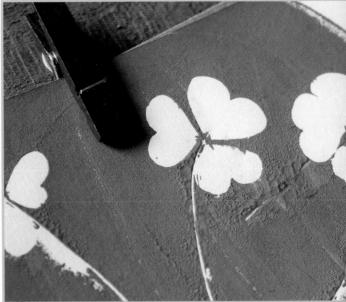

8 Lift the postcard from the scrap-paper surface and put it aside to dry. You can now place down a fresh postcard and fresh botanicals, and repeat the process to create a new, entirely unique design.

When you have printed a selection of postcards, keep them for reference and write on the reverse details of the found items, the paint you have used and guidance on the amount of pressure applied to pull the paint through the screen. This will help you to achieve similar results the next time you come to print.

CLEAR-DOWN AND DRYING

Wash your screen in a sink of hot, soapy water. Using a normal kitchen sponge, wipe the screen clean, and leave it to dry in a warm place. If you find that your silk comes loose, wait until your screen is completely dry, then open, reposition and retighten the silk, ready to print again.

Exposing is a print method that fixes a design permanently on a screen so that you can use it again and again, and store your design safely for future use. Here, I show you how to use a heat-resistant varnish to produce and transfer a design – exposing can be done outdoors, in natural daylight. The varnish helps keep the design in place on the silk, and will enable you to learn the exposing process without having to use complicated tools and equipment. Heat-resistant varnish is used most often for découpage but you can use it as a resist, and to give longevity to your screen printing designs.

In painting the design in varnish and using this as a resist, you will begin to understand the process of creating a design and transferring your own artwork onto a screen.

We continue the theme of botanicals with the motifs I have created especially for this chapter. In the projects that follow, you will learn how to transform two surfaces – cork and wood – with your printed designs.

You will need:

⚓ 12.7cm (5in) bamboo embroidery hoop mounted with habotai silk scarf (see pages 22–23)

⚓ Black ballpoint pen

⚓ Fine watercolour paintbrushes

⚓ Heat-resistant varnish

⚓ Any leaf template (see page 102)

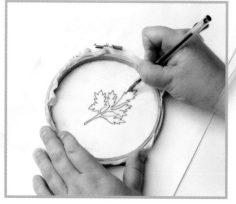

1 Place your pre-made hoop screen (see pages 22–23) screen-face-down over your chosen leaf template design. Make sure that you centre the design within the hoop.

2 Trace the leaf template directly onto the silk using a ballpoint pen. Avoid using a pencil or a pen without a roller-ball tip as these may snag the silk screen and affect the surface.

While you are tracing, try to keep the screw in the same position at the top of the hoop.

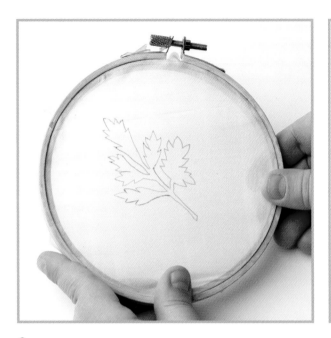

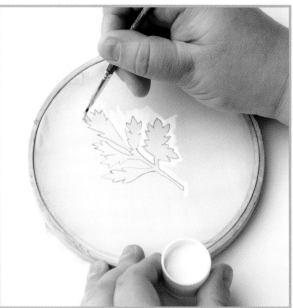

3 Flip over your hoop screen, ready to apply the heat-resistant varnish.

4 Apply the varnish evenly around the outside of the leaf design, using a paintbrush. Keep the application even and work from the centre outwards, right up to the edge of the hoop. This will enable an even application of varnish, seal the screen and ensure no paint bleeds through around the edges.

Use a fine brush to paint around the edge details of the leaf. The finer the brush you use, the more control you have over the process.

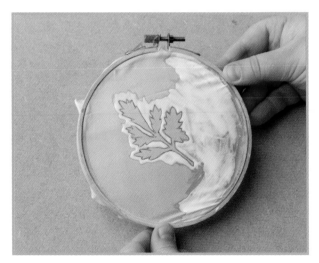

5 As the varnish needs to act as a resist when you're printing, ensure that you have covered all the areas of the screen around the edge of the leaf design. Hold the screen up to the light or over a contrasting worksurface – this will highlight any areas that have not been fully covered. Reapply more varnish in these areas.

DRYING

You will see the varnish turn clear when it is dry. The drying time will depend on how much varnish you have used. Leave your screen in a flat position or in a warm location to dry. You can also dry the screen with a hairdryer held from afar, or in front of a fan, as this gentle application of heat will not damage the screen surface. Once dry, your screen is ready to use.

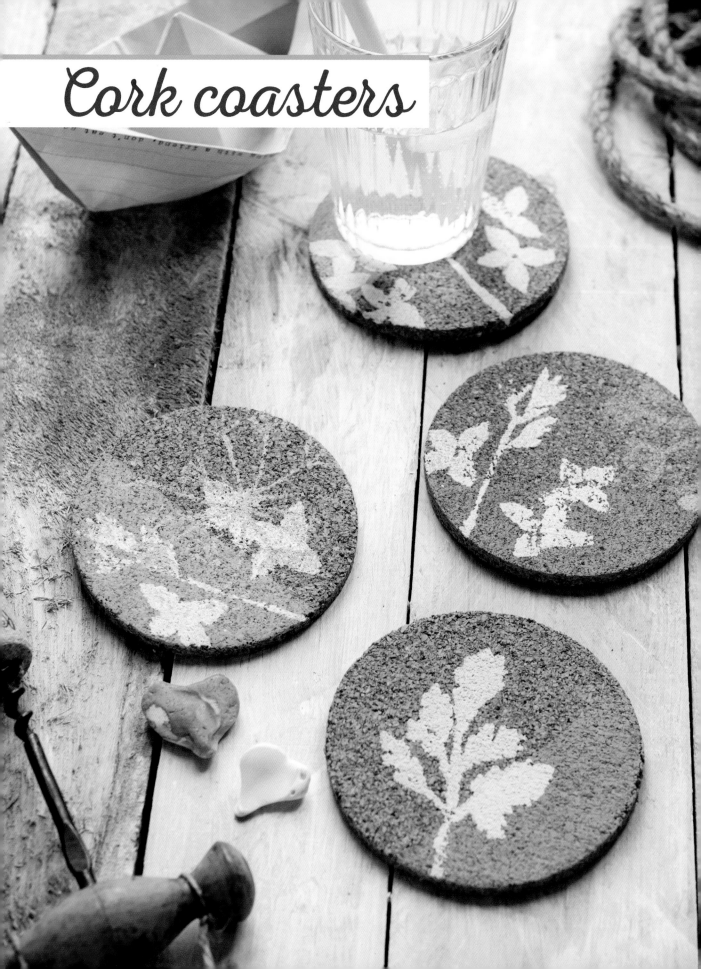

Cork coasters

You can now use your exposed hoop screen to print onto a textured surface. In this project, we will be using the hoop screen to print unique, bespoke cork coasters.

This project will help you develop your skills in printing with a hoop screen. It will also give you an idea of how simple it is to customize different objects and adapt your printing method to suit the print surface, depending on its thickness, for example.

The processes on the following three pages can be applied using any of the leaf motif templates on page 102 to create beautiful, layered designs. If, after you've printed the coasters, and the bunting on pages 34–37, you want to take these projects one step further and print onto a larger surface area, why not try printing onto cork placemats? These can be a great way to transform a simple table setting.

You will need:

- 12.7cm (5in) bamboo embroidery hoop mounted with habotai silk scarf (see pages 22–23), decorated with exposed leaf motif (see pages 28–29)
- Cork coasters, 9.5cm (3¾in) diameter
- Rollerball pen
- Single foam board or polystyrene sheet
- Cutting mat

- Craft knife
- Teaspoon
- 50ml (1.7fl.oz) each fabric printing paint in Butter, Atlantic Green, Violet, Mist and Cornflower shades (Pick Pretty Paints)
- Sponge dabber
- Masking tape

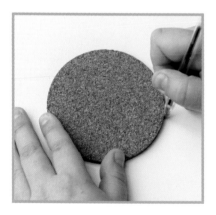

1 Place your coaster on the foam board and draw around it, using a ballpoint pen.

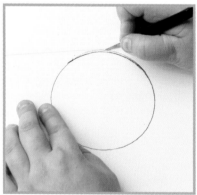

2 Place the foam board on the cutting mat. Cut out the circle with a craft knife to make a hole the same size as the coaster.

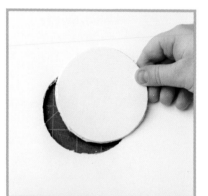

Note

The purpose of this hole is to keep the print surface area as flat as possible.

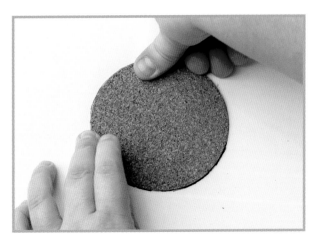

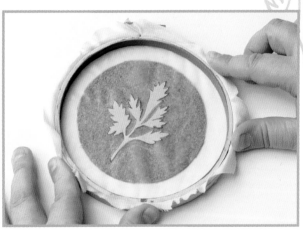

3 Press your coaster into the cut-out hole in the foam board. Placing the coaster flush in the hole in the foam board will prevent paint bleeding over the edge of the cork.

4 Position your exposed screen over the coaster – work out where you wish your design to be printed.

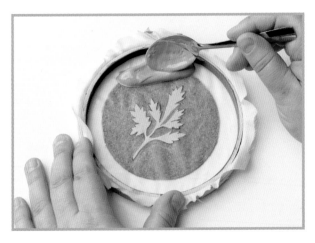

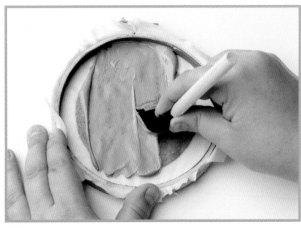

5 Use a teaspoon to apply a small amount of paint at the top of the cork coaster. You can always add more paint once you get used to printing on the cork surface.

6 Use a sponge dabber to pull down your paint over the coaster. Keep the sponge end at a 45-degree angle to the screen surface. Hold the sponge dabber at the base of the stick (nearest the sponge) – this will give you more control over the sponge.

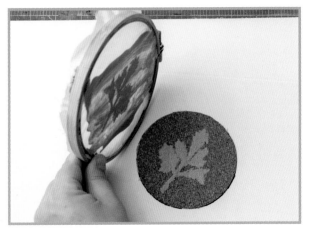

7 Lift up your screen from the bottom up, to prevent any paint being transferred onto other areas of the coaster.

Set your hoop screen aside, and remove the coaster from the foam board to dry, before positioning the next coaster to be printed.

Two-tone coaster design

To take your screen printed coaster designs further, why not try painting on a base colour to add depth? Use masking tape to create a strong, blocked-out area as a backdrop. Use a sponge or brush to apply paint in your chosen colour.

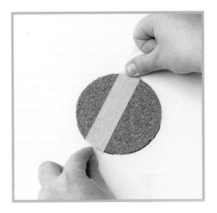

1 Press a fresh coaster into the cut-out hole in the foam board. Run a strip of masking tape across the coaster to mask out part of the print surface.

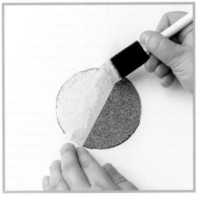

2 Using a sponge dabber, cover part of the coaster, above the masking tape, in paint (here, I've used the Butter shade).

3 Carefully peel off the masking tape. Allow the paint layer to dry.

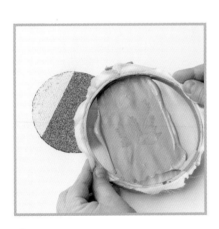

4 Position your exposed hoop over the coaster, and repeat steps 4 to 7 on page 32 to print the floral motif onto the coaster.

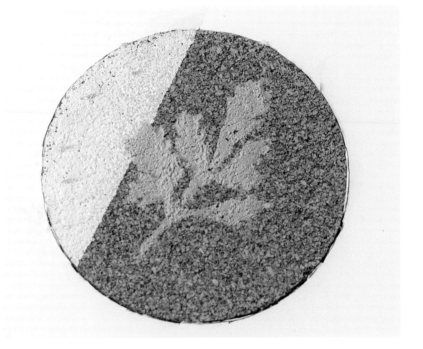

The printed two-tone coaster.

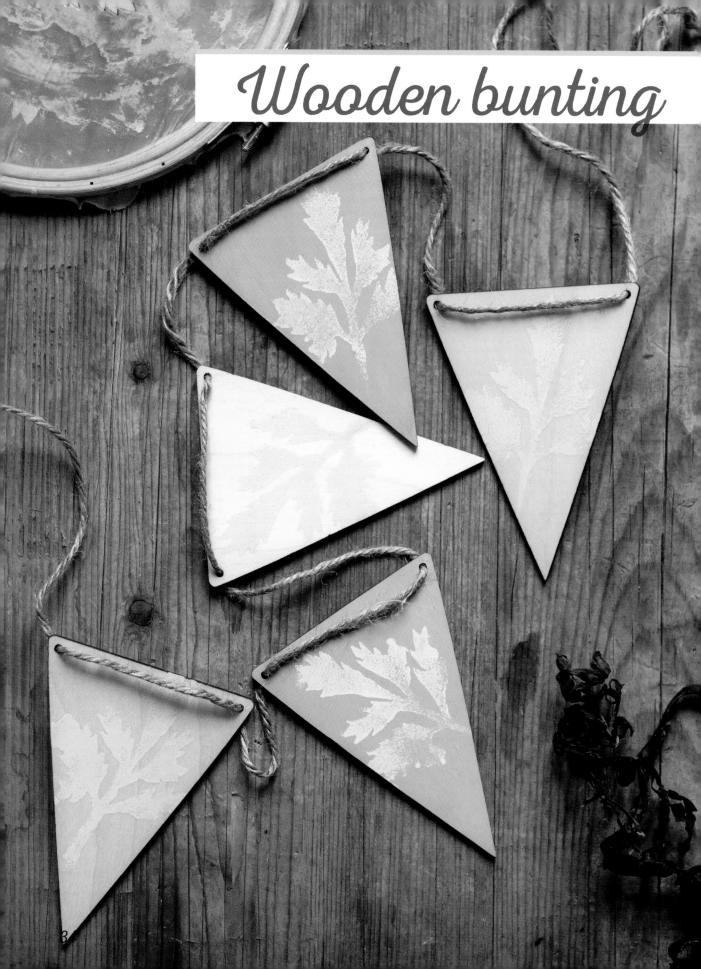

Wooden bunting

If you want to concentrate on using just one leaf motif, why not try printing onto a different surface – like plywood. In this project I show you how to print bunting flags using one hoop screen. You can make a beautiful, bespoke gift, or use the bunting to decorate your home. This is a project I particularly like to do at Christmas, when I can use the lightweight bunting to decorate my Christmas tree.

You will need:

- ⚓ 12.7cm (5in) bamboo embroidery hoop mounted with habotai silk scarf (see pages 22–23), decorated with exposed leaf motif (see pages 28–29)
- ⚓ Six (or more) pre-cut plywood bunting flags – 8 x 10.5cm (3⅛ x 4⅛in)
- ⚓ Sheet of paper or other plain surface
- ⚓ Ballpoint pen
- ⚓ Teaspoon
- ⚓ 50ml (1.7fl.oz) fabric printing paints in Mist and Cornflower shades (Pick Pretty Paints)
- ⚓ Sponge dabber
- ⚓ 1m (3¼ft) ribbon, wool or natural string/twine (to hang up the bunting)

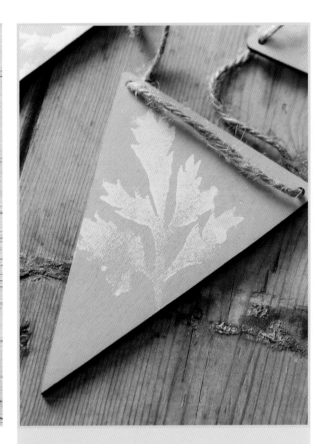

Note

As the plywood is thinner than the cork of the coasters, you do not need to create a well or foam board cut-out in which to sit each flag.

However, if any other surfaces you are printing onto are thicker than 1cm (⅜in), it is worth thinking about levelling out the print surface – the thicker the print surface, the harder the paint will be to control.

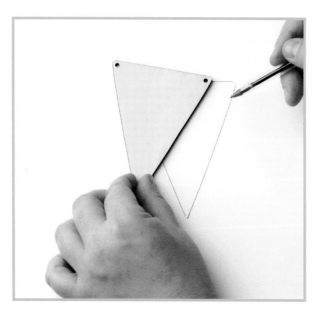

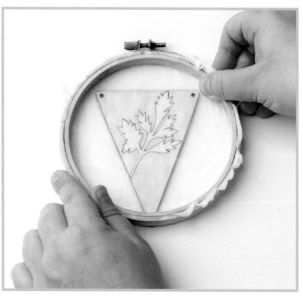

1 On a plain surface (such as a sheet of paper) draw around one bunting flag with the rollerball pen. This will give you a guide when you come to reposition or replace the flags in the same position each time you print.

2 Place your first flag on the guide you have drawn. Position your exposed hoop (see pages 22-23 and 28–29) on top of the flag, where you would like the design to sit.

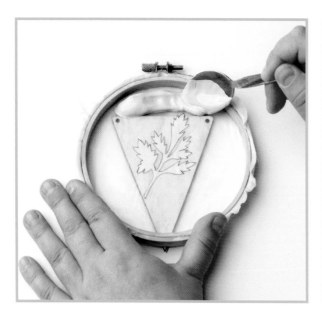

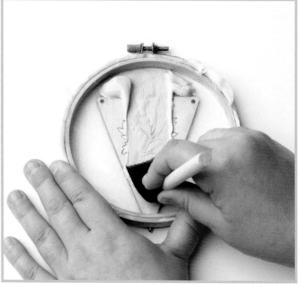

3 Decant the paint with a teaspoon at the top of the first flag (here, I am using the Mist shade). Note that you do not need to fill the whole hoop screen with paint – just the surface area of the flag.

4 Use a sponge dabber to pull down the paint through your hoop screen design. As the plywood is a hard surface, you may find that you have to adjust the pressure you apply when printing.

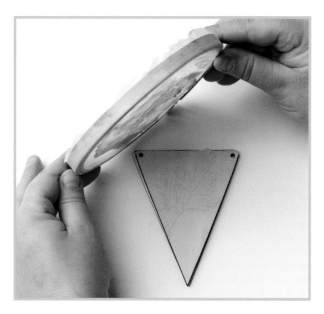

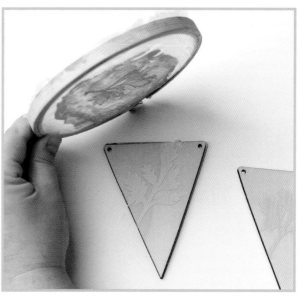

5 Lift the screen from bottom to top to reveal the printed bunting.

6 Position the next flag over the guidelines you drew at step 1, and repeat the steps to print again.

FIXING YOUR PRINTS

As this chapter has involved printing on different surfaces, please be mindful that the fixing process will depend on how you plan to use your bunting and cork coasters. Varnishes and spray fixers should be applied if you are going to use your bunting outdoors, or place hot items on top of the coasters. For these projects I like the matt finish, so I tend to leave the pieces as they are after printing.

However, if you wish to print this exposed motif onto fabric, follow the instructions on page 20.

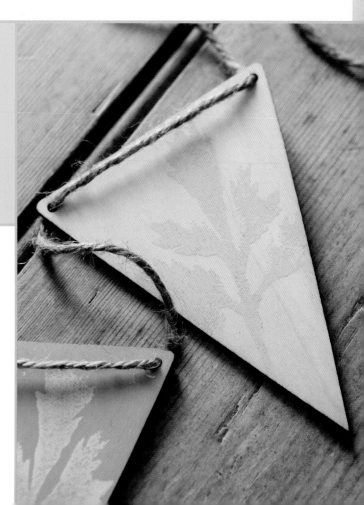

Using a wooden-frame silk screen

If you want to print multiple copies of the same design, screen printing enables you to repeat an image again and again onto a series of items so you can form a mini print production line.

I like to personalize gifts and often produce printed bags, using a wooden frame screen, to give to friends and family. This chapter will take you through the stages to help you do the same, as well as showing you how to use the same motif to print onto a linen tea towel (see pages 46–48).

The design for the projects in this chapter was inspired by a swallow I saw in my garden and painted in watercolour. From this motif, I created a simple template (see page 103) which can be transformed into a card stencil and attached to a hinged, wooden-frame silk screen.

You will need:

⚓ Wooden hinged frame screen, 36 x 43.5cm (14 x 17in)

⚓ Sheet of tracing paper, 29.7 x 42cm (11¾ x 16½in)

⚓ Sheet of medium-weight card for stencil, 29.7 x 42cm (11¾ x 16½in)

⚓ Swallow design template (see page 103)

⚓ HB pencil

⚓ Masking tape

⚓ Cutting mat

⚓ Craft knife

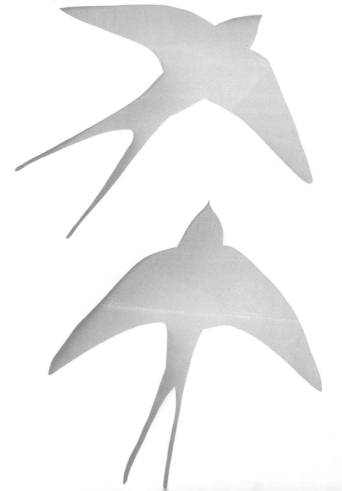

Making the stencil

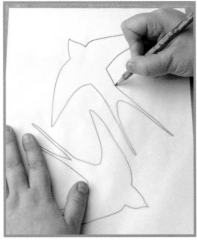

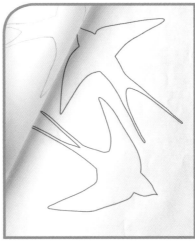

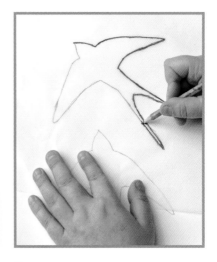

1 Position your tracing paper on top of the swallow design template (see page 103). You can tape down the tracing paper with masking tape to prevent it from moving around. Trace the swallow designs using an HB pencil.

2 Flip over the tracing paper and position the design centrally on the sheet of card. Use the pencil to rub the design through to the card surface.

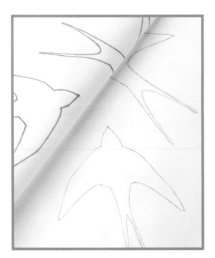

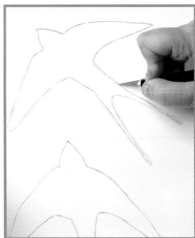

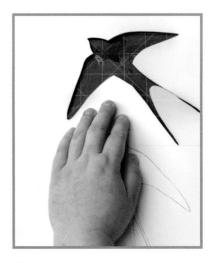

3 Lift the tracing paper to check that your design has transferred successfully onto the card.

4 Place the card on a cutting mat and cut out the swallow stencils with a craft knife. Take your time cutting out your stencils. Cut from the top to the bottom, and focus on cutting out smaller details first to prevent your stencil from misshaping or tearing.

5 When you've cut out each swallow shape, hold the stencil over a dark background (such as the cutting mat) to make sure that your cut edges are smooth and sharp.

Understanding your wooden frame screen

Ready-made printing frame screens usually come in kits complete with hinges, screws and a block base.

The block base raises the print area slightly from a worksurface, and gives a completely flat, smooth surface on which to print. Attaching your screen to a large, wooden block base can help with the consistency of multiple prints. The block base is made from smooth wood, onto which hinges and screws can be positioned and drilled in place to hold your frame in position.

The screws attach the block base to the frame and allow you to easily remove the screen to attach a card stencil and to wash down the screen after use. The wooden hinge rest makes it easier for you to be able to lift up your screen and contain the paint on the mesh or silk. This will also make the printing process speedier and more accurate when you are making multiple prints of the same design.

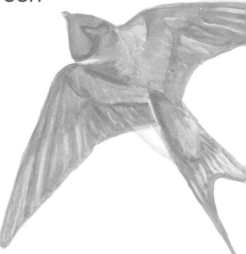

1. *Hinge*
2. *Block frame*
3. *Screw*
4. *Block base*
5. *Silk screen (translucent)*
6. *Hinge rest*

The assembled wooden frame screen.

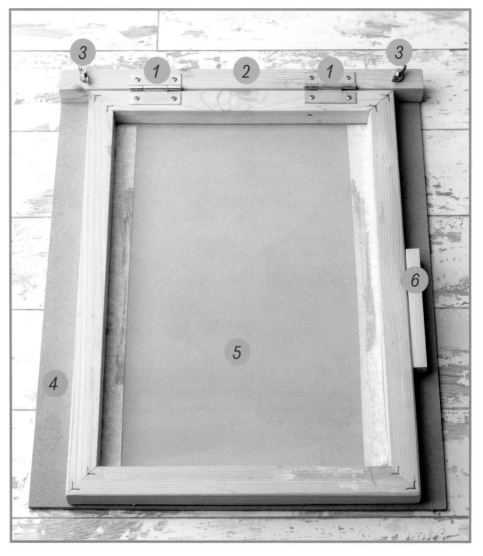

Attaching the stencil

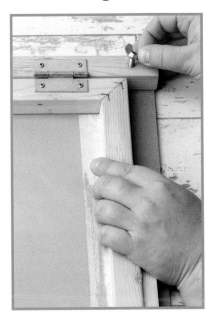

1 Use your fingertips to unscrew your screen at the top corners.

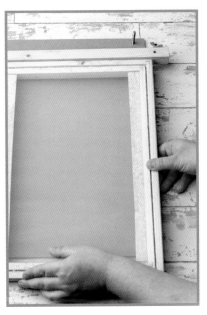

2 Place the frame with the screen face-down against the block base.

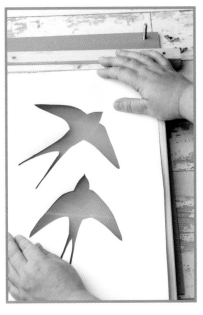

3 Position your stencil on the screen. Note that the stencil, too, needs to be placed face-down.

4 Tape the stencil to the frame using masking tape. Tape the shortest side first – this will help keep the stencil flat and prevent it coming loose.

Tip

When you have run masking tape along all four sides of the stencil, turn the screen over and check the edges to ensure they are secure and paint will not seep through.

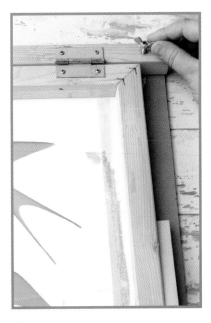

5 With the frame screen face-down again, position the frame back on the nails, and screw the screen back onto the block base. Your screen is now ready to use.

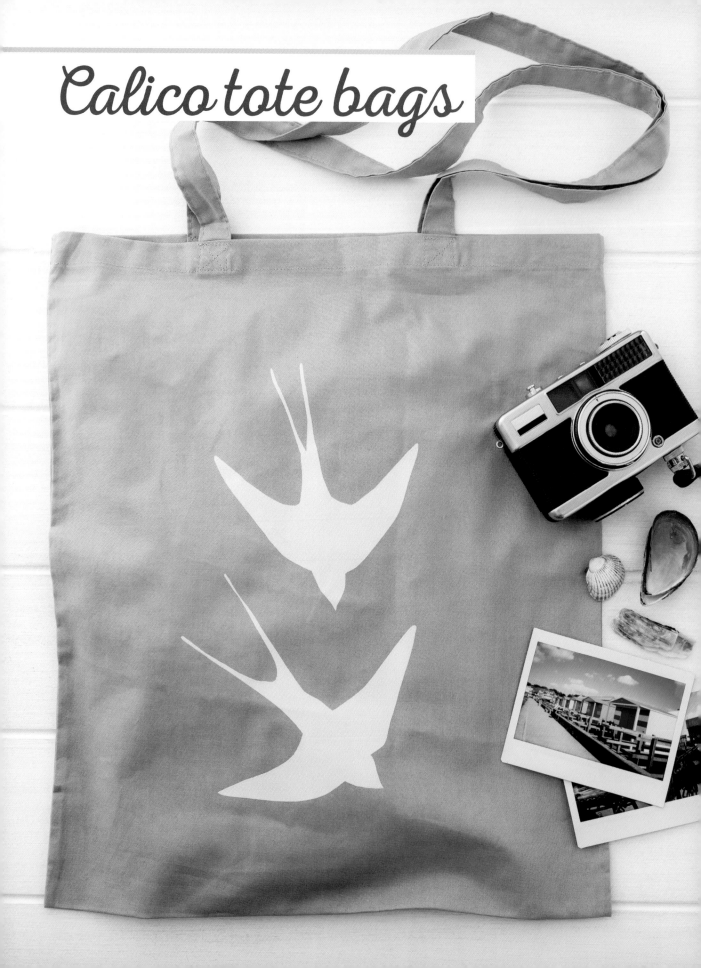

Calico tote bags

In this project you will learn how to use the frame screen and the stencil to print a series of calico tote bags with the swallow design.

You will need:

- Wooden hinged frame screen, 36 x 43.5cm (14 x 17in), mounted with swallow stencil (see pages 38–41)
- Blank calico tote bags, ironed – 36 x 42cm (14 x 16½in)
- Sheet of thin card or paper to fit inside bag – 29.7 x 42cm (11¾ x 16½in)
- Masking tape
- Teaspoon
- 250ml (8.7fl.oz) green fabric printing paint or water-based printing ink – I have used Lichen shade (Pick Pretty Paints)
- Palette knife
- Wooden-handled squeegee (these are often supplied with screen printing frame kits)

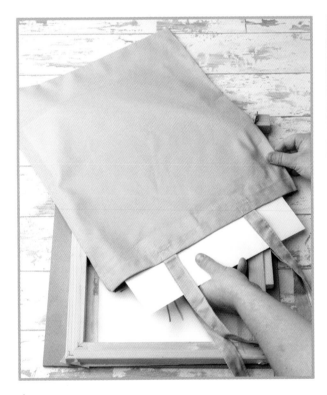

1 Put a sheet of thin card or paper inside the bag you are about to print on – this will keep the bag flat, and will also prevent paint seeping through the bag.

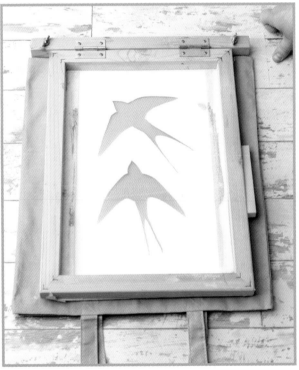

2 Place the bag under the screen. Make sure that it is centred and the edges are equidistant apart. Use masking tape to mark out the top corners of your bag on your worksurface – this will make it much easier for you to position each subsequent bag in the same place, for a mini production run.

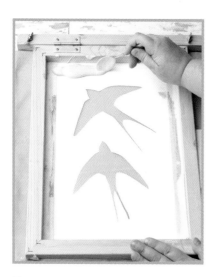

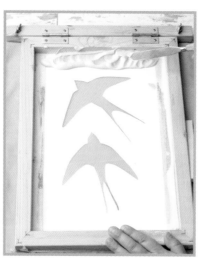

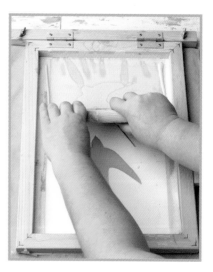

3 With a teaspoon, spoon out the paint at the top of the frame.

4 Spread out the paint evenly with a palette knife.

5 Position your squeegee on the paint at the top of the frame. Using both hands, pull the squeegee towards you, keeping it at a 45-degree angle to the screen. Apply a medium pressure and don't pull down the paint too quickly. This process is known as a 'pull-down'.

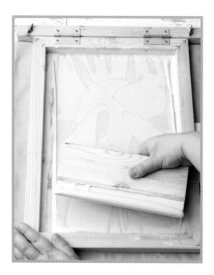

6 Repeat step 5 to pull the paint back through the screen again. Position your squeegee back at the top of the frame, ready for another pull-down.

THE PULL-DOWN

For most beginners, pulling the paint back up through the screen can be tricky after the first pull-down. If you do not feel confident about doing this, take your squeegee out of the frame and clean the excess paint off at the top of the screen with the palette knife (see below).

You may have to do a third pull-down if much of the paint is still sitting on top of the screen; normally, though, two pull-downs should be sufficient. The first pull-down is effectively a test print to check the amount of pressure you need. The more pressure you apply or the more pulls you make, the more likely you are to get overbleeding, which may lead to the paint flooding through the stencil and the screen onto the print surface.

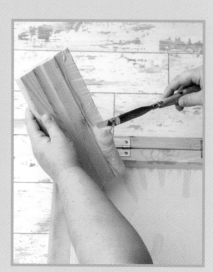

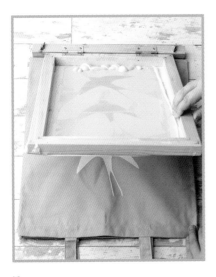

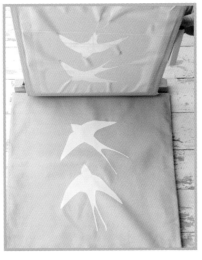

7 Gently lift up the screen to reveal your first print. Check that the fabric of the bag hasn't stuck to the screen. If you find your fabric is sticking to your screen, put some tape on the edges of each bag before printing again, to prevent this.

8 Use the hinge rest at the side of the frame to prop up the screen and keep it away from the printed bag. This will enable you to position your next bag before placing the screen back down, without transferring any paint from the screen to the clean bag.

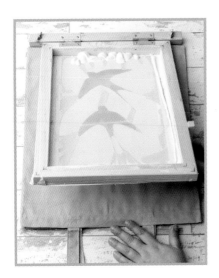

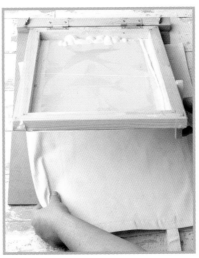

9 Slide your printed bag out from underneath the screen. Leave the tape markers in place.

10 Using the tape markers as a guide for placement, slide the next bag underneath the screen, and repeat steps 1 to 9 until you have printed all your bags.

FIXING YOUR PRINTS

Make sure you leave the bags to dry fully before washing them to fix your fabric design. Put a tea towel between the iron and the bag to prevent any paint from transferring onto your iron. See page 20 for more information on fixing.

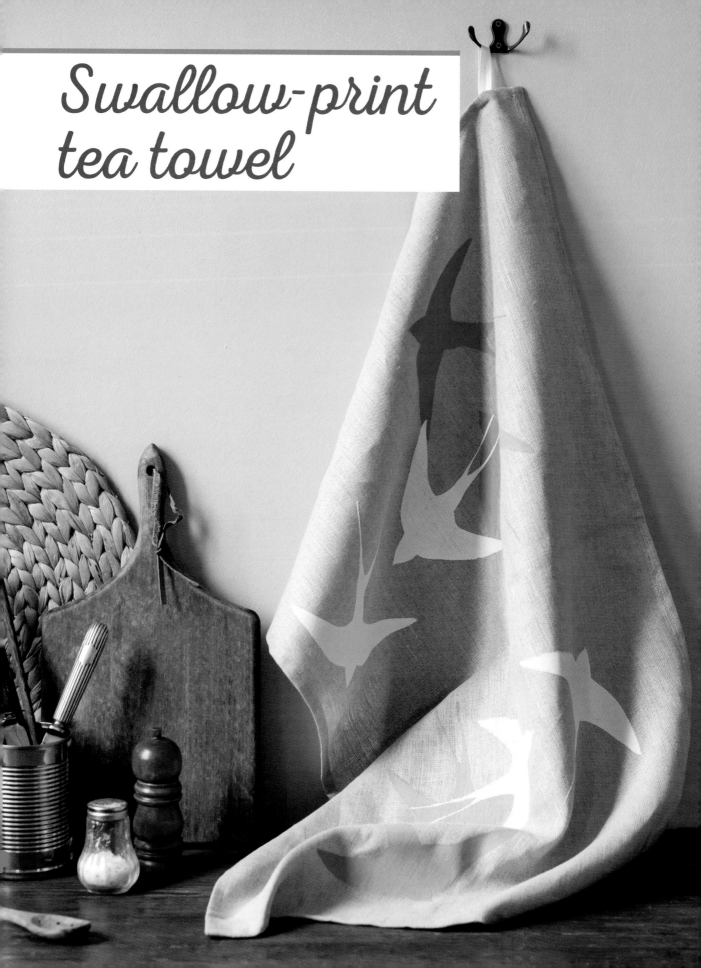

Swallow-print
tea towel

This project will show you how to print the swallow design twice onto one linen tea towel. The process can be applied to any fabric item such as a placemat or a table runner, as long as the surface is smooth. Positioning and rotating the tea towel to make a second print will give the appearance of a flock of swallows flying in different directions.

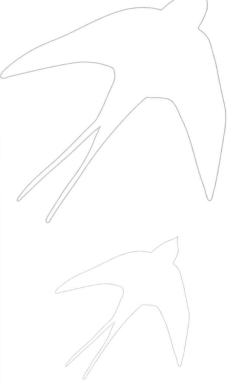

You will need:

- ⚓ Wooden hinged frame screen, 36 x 43.5cm (14 x 17in), mounted with swallow stencil (see pages 38–41)

- ⚓ Linen tea towel

- ⚓ 250ml (8.7fl.oz) green and lilac fabric paints or water-based printing inks – I have used Lichen and Lavender shades (Pick Pretty Paints)

- ⚓ Two teaspoons, one for each paint colour

- ⚓ Palette knife

- ⚓ Wooden-handled squeegee (often supplied with screen printing frame kits)

Make the stencil and attach it to your frame screen following the instructions on pages 39 and 41.

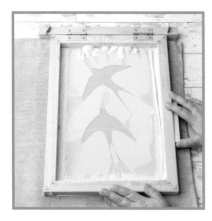

1 Position your tea towel horizontally in relation to your screen. This will help you see how much space you have available to print.

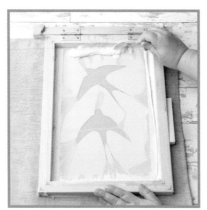

2 Spoon paint onto the screen at the top.

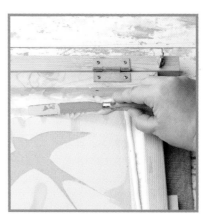

3 Spread out the paint with a palette knife.

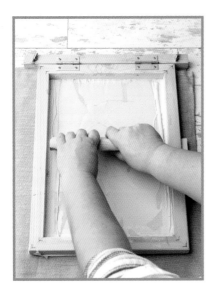
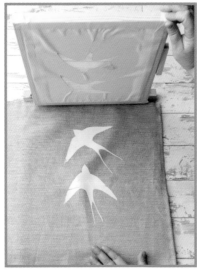
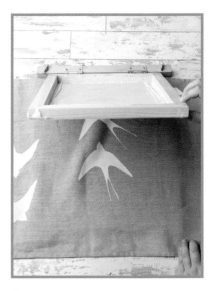

4 Hold and pull down your squeegee with medium pressure. Keep the squeegee at a 45-degree angle to the screen. Repeat the pull-down once, or twice if necessary.

5 To reveal your first print, lift up the screen slowly and carefully. You can use the hinge rest at the side of the frame to prop up the screen, to keep it clear of the fabric.

6 Rotate the fabric 180 degrees so that the screen is directly above the space where the next print will be positioned. Make sure you leave enough space so that the lowered screen will not touch your original print. Lower the screen back onto the tea towel. Repeat steps 2 to 4 to print the next pair of swallows, then slowly lift up your screen to reveal your print.

TAKING IT FURTHER

To take your project one step further, print swallows in a second colour on your tea towel, to make a two-layer swallow formation (see above). Make sure your first layer is completely dry before you print a second colour.

FIXING YOUR PRINTS

Allow your tea towel to dry fully before washing it to fix the fabric design. See page 20 for more information on fixing.

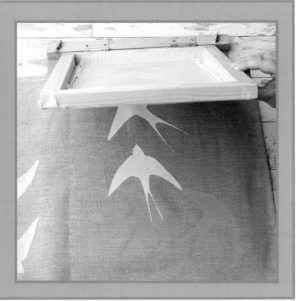

As a progression from printing singular motifs, creating patterns in screen printing can be a daunting prospect, but once you know the basics, a repeat pattern or a printed border can transform a plain piece of fabric or garment.

Over the following pages, I show you how to create repeated patterns using feather silhouette stencils and an acetate template guide. Once you have gained confidence in placing, and re-placing, the stencil and the template alongside one another, you will be able to attempt more complicated repeats and layers.

You will also learn how to place a feather silhouette stencil on a small metal frame screen consistently around the hem of a skirt to print an effective border repeat. The small metal frame screen will give you more control when you are positioning and repositioning the print on the fabric. You will find it easier to change the direction of the pattern and see the print appear as you work across the fabric.

REPEATS AND BORDERS

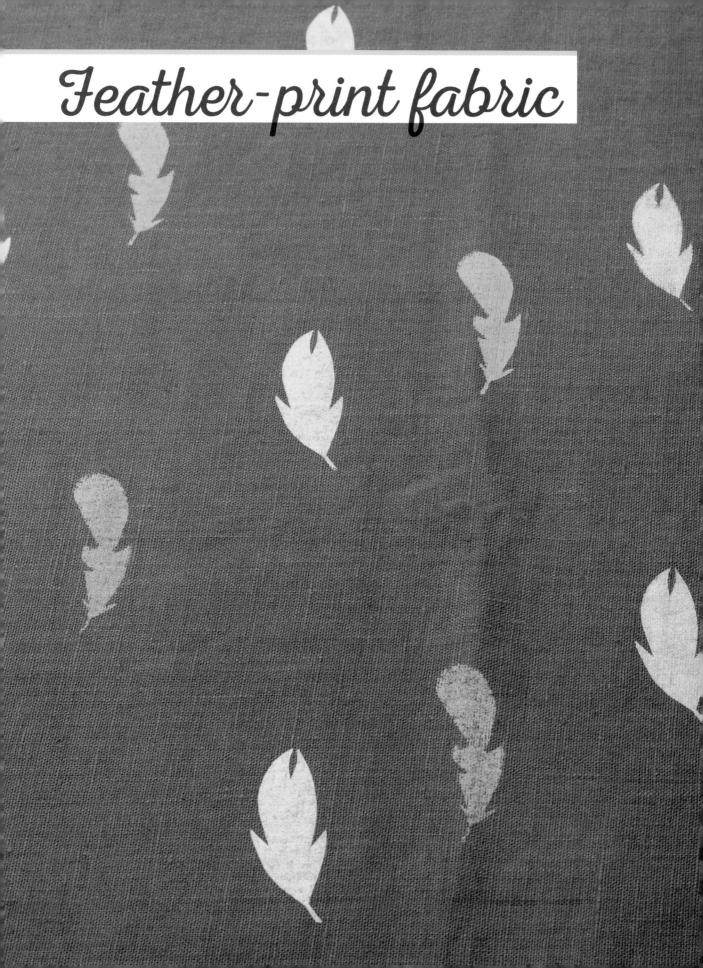

Feather-print fabric

The length of fabric on the opposite page has been printed using a screen printing method known as the 'half-drop repeat'. This effect occurs when your design is 'dropped' and directed down the fabric, in a diagonal pattern.

It is best to work a half-drop repeat on a flat, smooth table – this will make it easy for you to position the fabric and use the edge of the table as a guide as to where to print.

The acetate used to make the stencils and the template guide ensures that the design lasts longer, and is more durable, than on card. Likewise, the small metal frame has a wide, easy-to-grip rim that makes this frame ideal for printing and repositioning on larger surface areas.

You will need:

⌁ Ballpoint pen

⌁ Cutting mat

⌁ Craft knife

⌁ Lightweight acetate sheets, 21 x 29.7cm (8¼ x 11¾in)

⌁ Small metal frame screen, 14.8 x 21cm (6 x 8¼in)

⌁ Feather templates (see page 104)

⌁ Masking tape

⌁ 1m (3¼ft) natural medium-weight linen

⌁ Small plastic and rubber squeegee

⌁ 100ml (3.5fl.oz) each of fabric paints – I have used Clay and Coral shades (Pick Pretty Paints)

⌁ Two teaspoons, one for each paint colour

⌁ 30cm (12in) ruler

⌁ Old tablecloth (optional)

⌁ Pins (optional)

Making the stencil

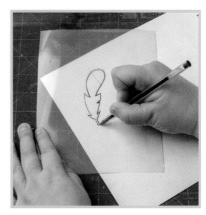

1 Draw around the outside of the metal frame screen with a ballpoint pen onto two acetate sheets. Cut them both to the size of the frame. One sheet will be used to make the stencil and the other to make the template guide.

2 Trace a feather silhouette design from page 104 onto one of the acetate sheets.

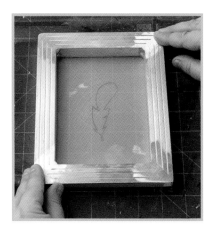 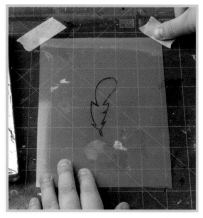 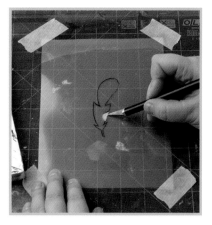

3 Position the acetate under the metal screen to check that the stencil design is central.

4 Tape the acetate to your cutting mat to stop it from slipping while you cut out the feather.

5 Use a craft knife to cut out the feather silhouette. Cut out small details first – this will help you maintain control when you cut out the full stencil. Make sure that the blade of your knife is sharp and tight, as acetate is thicker than card, making it much harder to cut.

Attaching the stencil

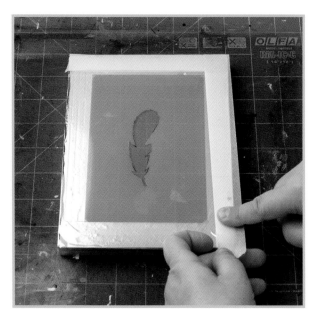 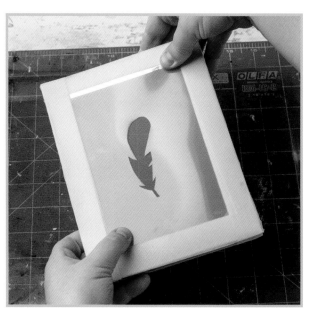

1 Position the stencil on the back of the metal screen and secure it along all four edges with masking tape. Make sure that all the edges are fully covered, to prevent any paint from coming through.

2 Double-check that the stencil is secure and tight, like a drum head, by running your hand over it. If the acetate stencil moves or buckles, untape it and reposition it.

Printing the template guide

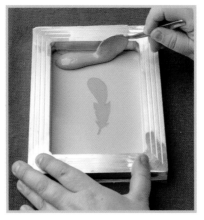

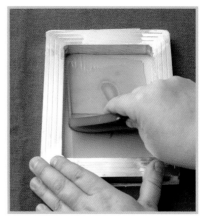

1 Tape the second sheet of acetate to the surface of the fabric on which you will be printing. You are going to print directly onto the acetate sheet. Place the metal frame screen and stencil directly on the top of the acetate.

2 Spoon a small amount of paint onto the top of the screen – this is the Clay shade.

3 Hold a small plastic squeegee at a 45-degree angle to the screen. Pull the paint through the stencil onto the acetate underneath.

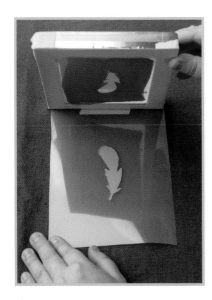

Note

Wait for the template guide to dry. If the print has smudged slightly, don't panic: the acetate print is for use as a placement guide only and can be discarded after you have printed the fabric.

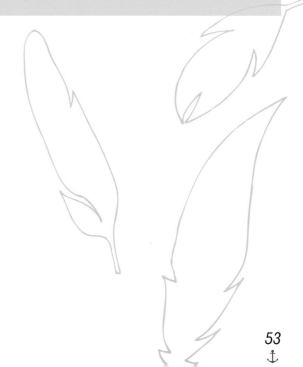

4 Lift up the frame from the bottom to the top and set it aside. Remove the printed acetate template guide to dry in a warm place before you begin the half-drop repeat (overleaf).

Beginning the half-drop repeat

A half-drop repeat should start at the top-left of the print surface. This is to guide the direction of the print in a consistent diagonal across the fabric. After the first row, you will start to see the sequence formation evolving.

Tip

As the fabric is a larger surface area than you've printed on before, you may wish to attach the fabric to the rest surface underneath, to avoid the print surface slipping or moving. Put an old, flat tablecloth underneath your fabric and pin or tape the fabric to the tablecloth to hold it in place. Be careful not to secure the fabric too tightly, however, as you will need to move it later on, when you are printing further rows and layers.

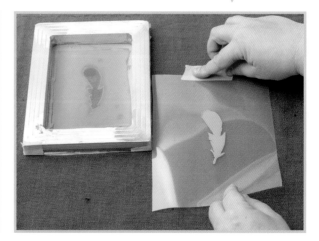

1 Remove the printed acetate sheet – the template guide – from the fabric. Place the metal frame screen in the top-left corner of the fabric. Reposition the acetate template guide flush alongside the right edge, and halfway down the length, of the metal frame screen and attach it to the fabric with a single strip of masking tape along the top edge.

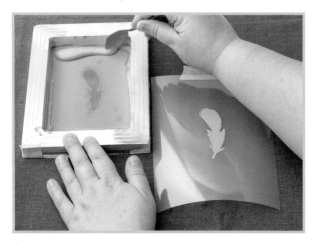

2 With a teaspoon, pour a small amount of paint (here, I am using the Clay again) into the well of the frame, at the top of the screen.

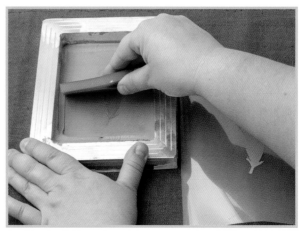

3 Use the small plastic squeegee to pull the paint firmly down the frame, through the screen. Hold the squeegee at a 45-degree angle to the screen. You may need to pull through the paint two or three times, depending on the thickness of your fabric.

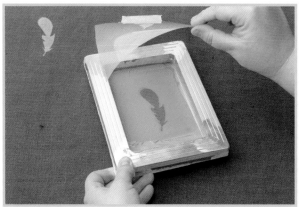

4 Lift the frame screen from bottom to top to reveal your first print.

5 Lift the template guide. Place the metal frame screen underneath the acetate sheet.

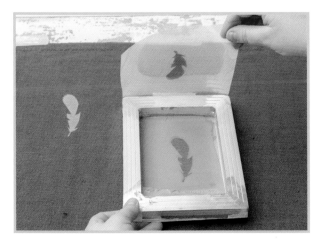

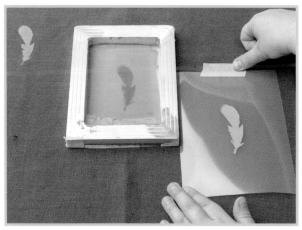

6 Position the frame beneath the template guide so that the feather stencil is directly underneath the feather print on the acetate.

7 Remove and reposition the acetate template guide so that it sits flush against the side of the frame, and about halfway down the length, as in step 1 – hence 'half-drop'.

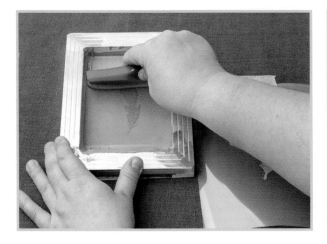

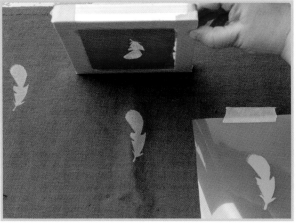

8 Use the small squeegee to pull the paint through the screen.

9 Lift the frame screen from bottom to top to reveal the second print.

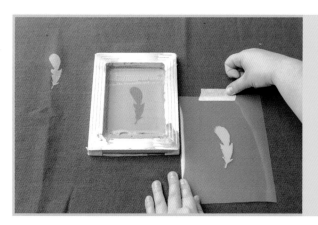

Tip

Remember when you have printed a design to then move and reposition your acetate template guide halfway down the right-hand edge of the metal frame screen before taking the frame away. You will start to see the pattern and the rhythm of the repeat forming.

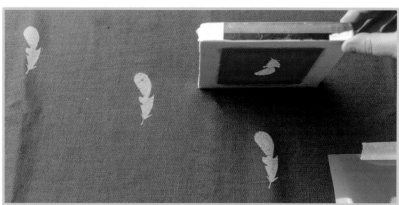

10 Keep repeating this process until you reach the right-hand edge of the fabric. You can then progress to printing your second row of repeats.

Tip

Use a ruler along the right-hand side of the frame or the acetate to help you keep your repeat straight.

The second row

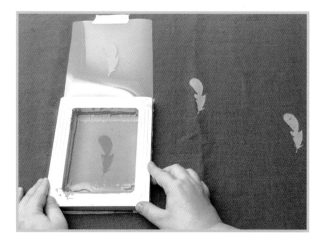

11 To start the second row of half-drop repeats, reposition and stick the template guide over the top of the first feather you printed (on page 54). Place the metal screen directly underneath, and flush to the bottom edge of, the acetate.

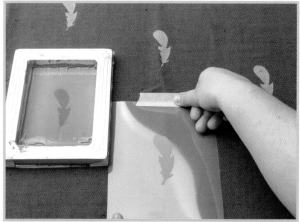

12 Remove and reposition the template guide alongside the metal frame screen as before – halfway down the right-hand edge of the frame.

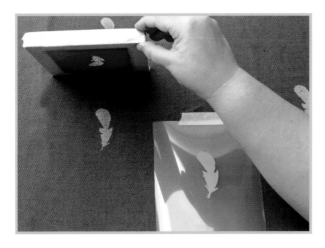

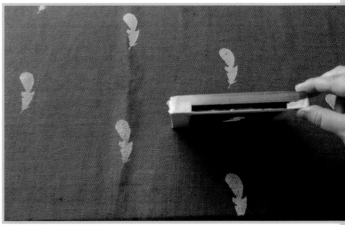

13 Print the first feather in the second row directly beneath the very first feather.

14 Follow steps 5 to 10 on pages 55–56 to continue the half-drop repeat pattern, and create rows of feathers until you reach the bottom edge of your fabric.

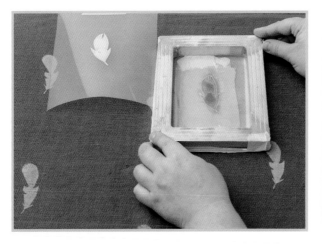

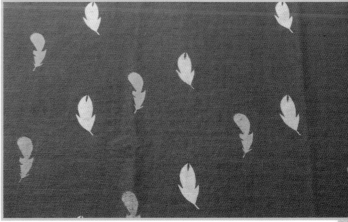

The fabric printed with the half-drop repeat pattern in multiple rows.

15 Choose a second feather design from the templates on page 104. While the first set of printed feathers is drying, follow the steps from page 51 onwards to transfer a new stencil to your screen and print the second layer of feathers in between the first, in a different colour paint – here, Coral. Continue to print until you reach the bottom-right corner of the fabric.

TAKING IT FURTHER

If you feel that developing half-drop repeats is something you wish to explore in more depth, use your small metal frame screen to build up multiple layers using the techniques explained here, then rotating the screen from portrait to landscape (tall to wide). This will make the half-drop repeat seem more complicated in its detail.

You may also consider using frames and designs at different sizes and building up layers of prints at varying scales – this can also make a pattern appear more detailed.

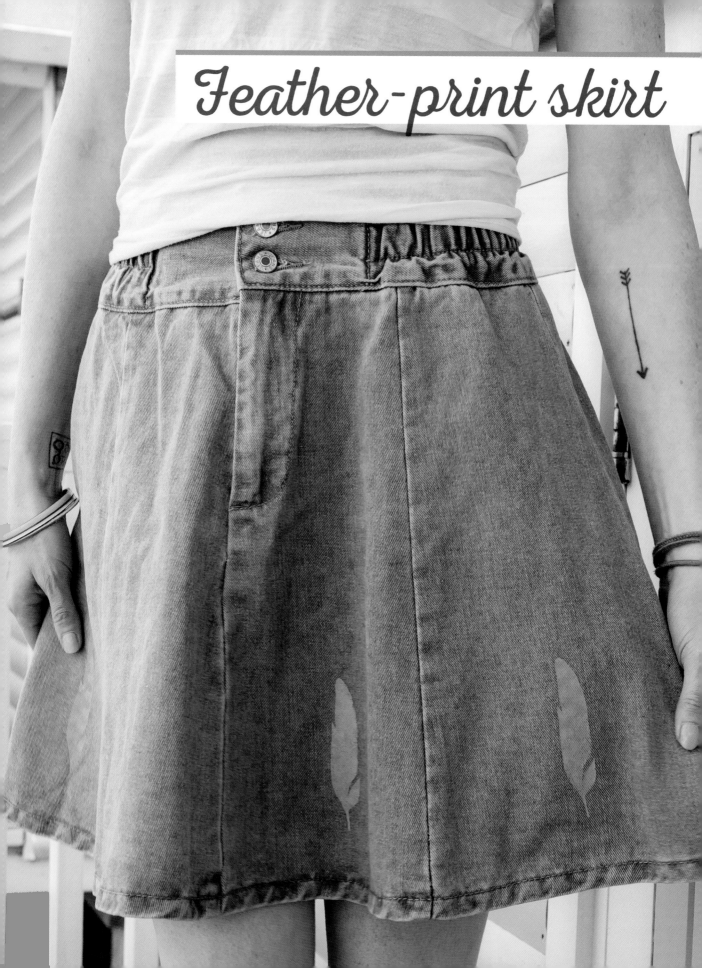

Feather-print skirt

A border repeat is a simple and attractive way to customize an item of clothing such as a plain, hemmed skirt. Border repeats are created by spacing your pattern evenly along the border of your print surface. You can use an acetate template guide as for the half-drop repeat if you would like.

In this project, which is of a smaller scale than the half-drop repeat in the previous project, you can use an ironing board as a worksurface. This will enable your skirt to hang off the edge of the surface and be rotated easily as you print your feather border.

Use one of the feather motifs from the half-drop repeat exercise, or choose a different stencil design from page 104 to mount on the metal frame screen, following the steps on pages 51–52.

You will need:

⚓ Small metal frame screen, 9 x 12cm (3¾ x 4¾in) mounted with acetate stencil (see pages 51–52)

⚓ Acetate sheet for template guide (optional)

⚓ Feather templates (see page 104)

⚓ Plain, hemmed skirt in a natural fabric such as cotton or denim

⚓ Ironing board (to be used as a worksurface)

⚓ Old tea towel or 50cm (20in) calico or scrap fabric (to place between your skirt and the ironing board)

⚓ Pins (optional)

⚓ Dressmakers' tape measure

⚓ 100ml (3.5fl.oz) fabric paint – I have used Cornflower

⚓ Teaspoon

⚓ Small plastic and rubber squeegee

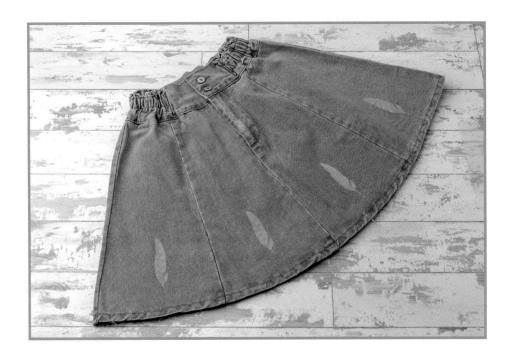

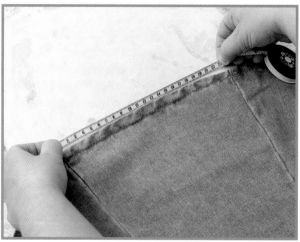

1 Lay or pin an old tea towel or piece of scrap fabric over your ironing board and slip the skirt over the board, with the hem facing away from you. This will give you more surface area and space on which to print.

2 Measure the hem of your skirt to calculate how many feather prints you will be able to fit on it – measure the circumference of the hem and divide this measurement by the width of the metal frame.

 If your project features a panelled skirt, as shown here, it is helpful to measure each panel so you can work out, roughly, where the centre of the panel is, and place the design centrally each time you print.

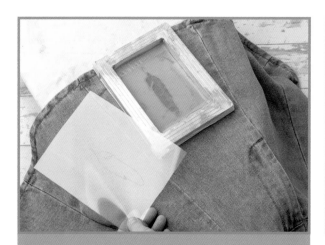

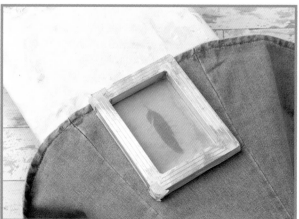

Tip

If you want to ensure that your designs are evenly spaced around the skirt, or if you are not printing on a panelled skirt, follow the instructions on page 55 to make a separate acetate template guide that you can place flush alongside the frame before you reposition the screen for the second print.

3 Place your metal frame screen on the skirt so that the design is the right way up on the garment – with the stalk of the feather pointing towards the hem. Line up the bottom edge of the frame with the bottom of the hem. If you are printing on a panelled skirt, ensure that the design is central in relation to the seams of the panel.

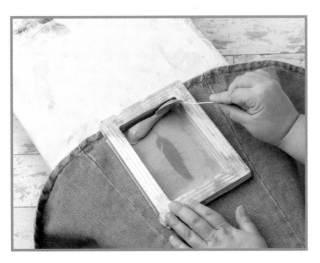

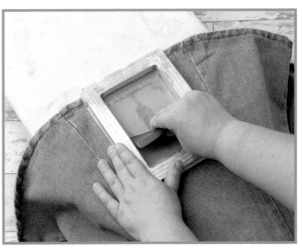

4 Spoon the paint into the well of the frame, along the edge of the screen furthest from you.

5 Pull down the paint, keeping the squeegee at a 45-degree angle to the screen. Depending on the thickness of the skirt, you may need to pull down the paint two or three times.

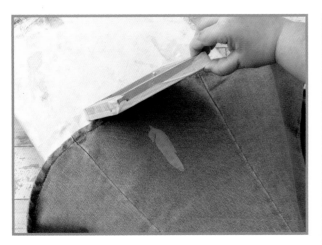

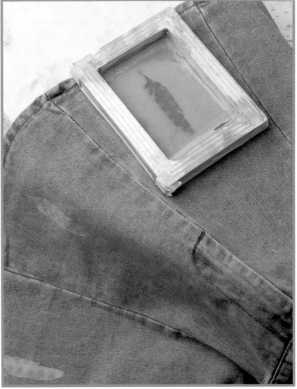

6 Lift up your frame screen from bottom to top to reveal your first border print.

7 Rotate the skirt around the ironing board. Reposition the frame screen centrally in the next 'empty' panel – use a template guide to place the design evenly in relation to the previous print, especially if you are not printing on a panelled skirt. Repeat steps 3 to 6 until you have completed your border. Peg or hang up your skirt to dry.

FIXING YOUR PRINTS

Make sure your prints are completely dry before fixing the design and washing the skirt. See page 20 for more information.

As you progress from half-drop repeats and border repeats, there are many other ways in which you can create patterns with screen printing. Tessellations, or tessellation repeats, are tiled patterns in building block formations; the patterns in this demonstration are printed with both the metal frame screen and the hoop screen, which you have already learned to use. The metal frame screen will be fitted with a card stencil this time.

While the half-drop repeat patterns on pages 50–57 use a separate, acetate template guide as a marker to place your prints, you can also use the screens themselves as markers to print the two designs – a sailing boat and an anchor – equally, in a chequerboard pattern.

For this project I have printed two different fabrics and made them into cushion covers – you can use the printed fabrics however you would like.

You will need:

⚓ Large sailing boat and anchor templates (see page 105)

⚓ Small metal frame screen, 9 x 12cm (3¾ x 4¾in)

⚓ 12.7cm (5in) bamboo embroidery hoop mounted with habotai silk or silk scarf and exposed with the anchor template (see pages 22–23 and pages 28–29)

⚓ Selection of small, fine paintbrushes

⚓ Heat-resistant varnish (see page 13)

⚓ Sheet of tracing paper, 21 x 29.7cm (8¼ x 11¾in)

⚓ Sheet of card, 21 x 29.7cm (8¼ x 11¾in)

⚓ Cutting mat and craft knife

⚓ Ballpoint pen

⚓ Masking tape

⚓ Natural medium-weight linen or cotton

⚓ Lightweight acetate sheet, 21 x 29.7cm (8¼ x 11¾in)

⚓ Ruler – a long ruler is ideal

⚓ Scissors

⚓ Plastic squeegee

⚓ 100ml (3.5fl.oz) each of fabric paints in Butter and Sage shades (Pick Pretty Paints)

⚓ Two teaspoons, one for each paint colour

⚓ Sponge dabber

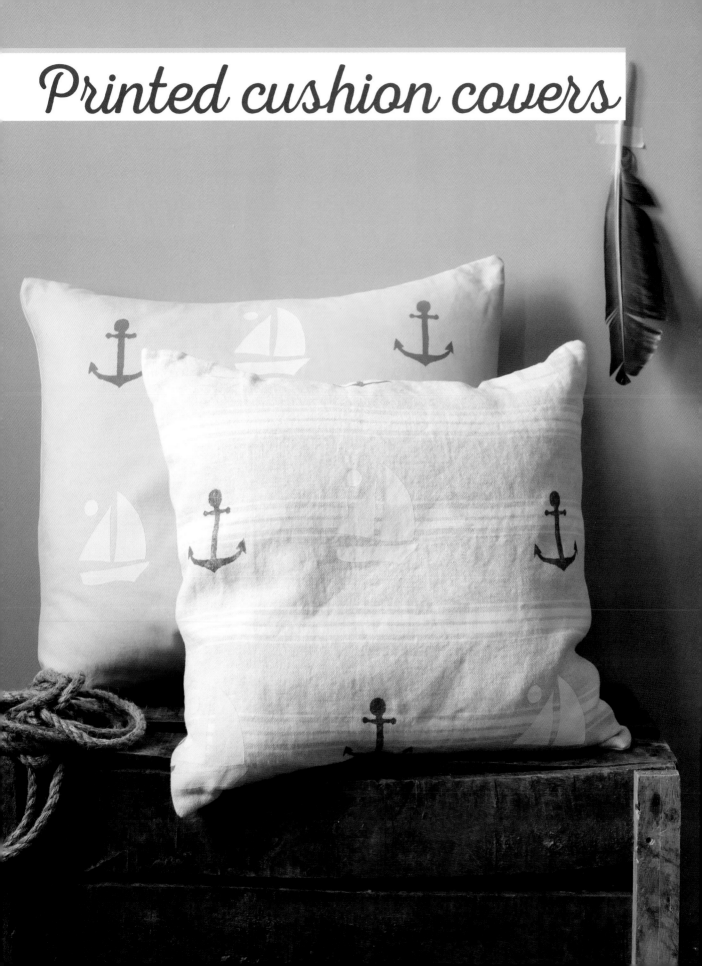

Printed cushion covers

Preparing the metal frame screen

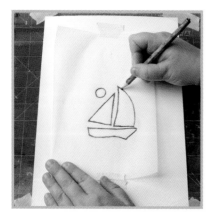

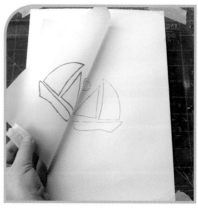

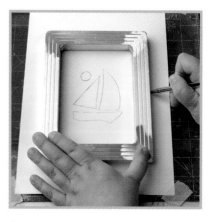

1 Trace the sailing boat stencil from page 105 onto tracing paper and transfer it to a sheet of card.

2 Draw around the outside of the metal frame screen onto the card using the ballpoint pen. Ensure that the design sits in the centre of the frame.

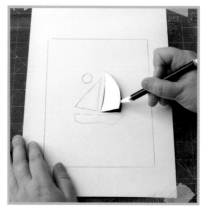

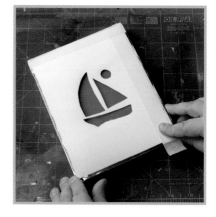

3 Remove the frame.

4 Use a craft knife to cut out the sailing boat stencil, then cut out the shape of the frame.

5 Following the steps on page 52 for the feather project, attach the stencil to the back of the metal frame screen with masking tape.

Preparing the hoop screen

Follow the instructions on pages 28–29 to make and expose your hoop screen, using the anchor template on page 105.

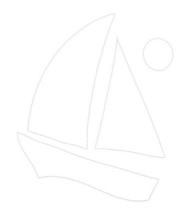

Printing the boats

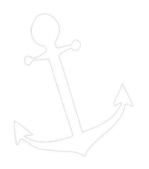

Print one design at a time: start with the boats in the metal frame screen. Printing with both screens at the same time will become too complicated and messy, and may cause paint to transfer from one screen to the other.

Make an acetate spacer guide to keep the space between your prints consistent.

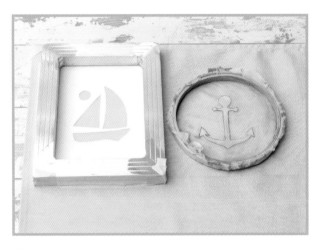

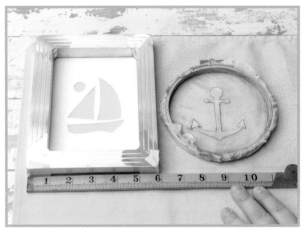

6 Lay your fabric on a flat surface. Tape or pin down the fabric along the top edge to ensure you keep a straight line in your repeat print. Lay down your metal screen in the top-left corner of your fabric. Place the hoop alongside the frame so that the designs are roughly lined up.

7 Measure the widths of the metal frame screen and the hoop frame. Use the wider measurement to work out how much space to leave between the boat prints to allow space for the anchors. The metal frame screen in the photograph above is 15.2cm (6in) wide while the hoop frame is 12.7cm (5in) wide – 15.2cm (6in) will give you plenty of room in which to print the anchors.

8 To keep the spacing between prints consistent, draw around the metal frame screen onto an acetate sheet to create a spacer guide.

9 Cut out the shape of the metal frame from the acetate. The spacer can now be used to ensure there is an even space each time between the sailing boat prints, and from page 69, the anchor prints.

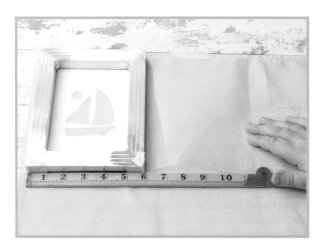

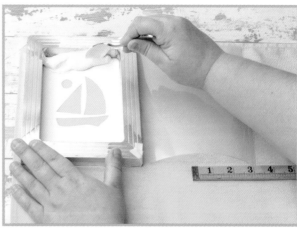

10 Place the metal frame screen at the top-left corner of the fabric. Place a ruler under the bottom edge of the screen so that when you position the spacer next to the frame, the row of prints will stay straight. When the spacer is in place, tape it to the fabric along the top edge of the acetate.

11 Apply a small amount of paint at the top of your metal screen with a teaspoon – for the sailing boat, I am using the Butter shade.

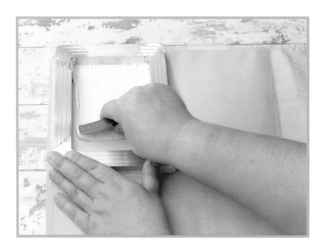

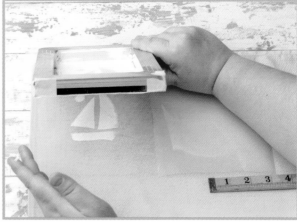

12 Pull the paint down the screen using the mini plastic squeegee.

13 Lift your screen from the bottom upwards to reveal your first print.

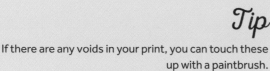

Tip

If there are any voids in your print, you can touch these up with a paintbrush.

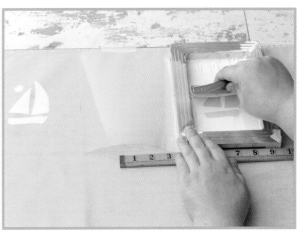

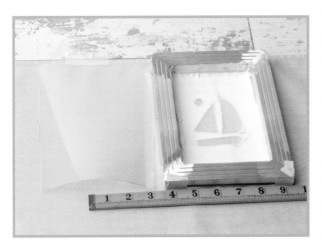

14 Place your ruler at the bottom of the frame screen and use it as a guide to reposition the frame on the right-hand edge of the acetate spacer. The spacer will give more than enough space to print the anchor motifs in between the boats on page 69.

15 Repeat steps 11 to 13 to print your second boat motif.

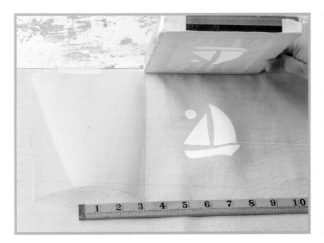

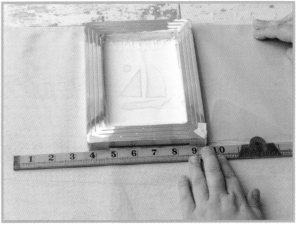

16 Lift up your frame to reveal the second sailing boat print.

17 Lay down the frame. Move the acetate spacer to the right of the frame, then repeat steps 11–15 to print a series of boat motifs, until you reach the right-hand edge of the fabric.

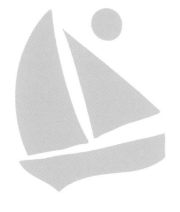

The second row

You can now print a second row of tiled sailing boats.

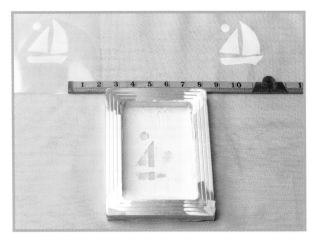

18 Keeping your ruler underneath the top row of prints so that your print line remains straight, place the frame screen below, and between, the top-left two boat prints.

19 Follow steps 11–13 on page 66 to print the first boat on the second row.

20 Move down the acetate spacer to the right of the metal frame screen, before moving the frame over to the right of the acetate spacer. Print the next boat motif.

21 Follow the process of moving the acetate spacer across to the right of the frame, then the frame to the right of the spacer, and printing the boat motifs until you reach the bottom of your fabric. Leave the boat prints to dry and wash out your screen before you begin printing the anchor motifs.

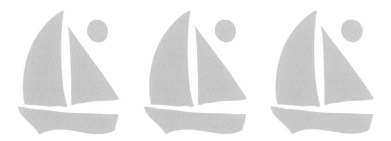

Printing the anchors

You are now ready to print the second motif and fill in the gaps between the boat prints in a chequerboard pattern.

 Although you are now using a circular hoop, you will still need to be mindful of keeping an equal distance between your prints. Use the acetate spacer to remind you where the frame edges start and finish during the print process.

 Keep moving your spacer along the fabric as you print – this will get you into a rhythm that helps you complete your tessellating pattern.

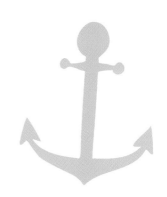

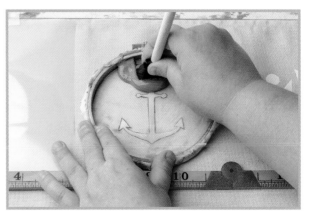

1 Place the acetate spacer over the top of the first boat you printed (see page 66). Lay your ruler underneath the spacer, then position your embroidery hoop in between the first two boat prints. Ensure that the exposed anchor motif is positioned centrally between the boats.

2 Apply paint to the hoop screen, this time using a sponge dabber and the Sage fabric paint. Remember to hold the sponge dabber at the base of the stick nearest the sponge for greater control over the sponge and the paint.

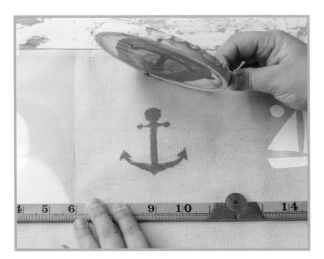

3 Lift your hoop from bottom to top to reveal your first anchor print.

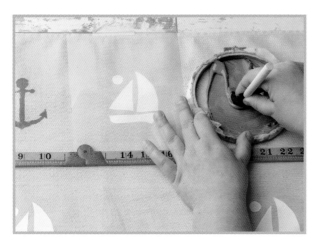 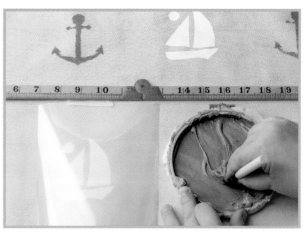

4 Place the spacer over the top of the second sailing boat. Position the hoop screen between the second and third printed boats. Repeat steps 2 and 3 to print the second anchor.

 You will start to see the chequerboard pattern evolve.

5 You should find that you will get into a rhythm of repositioning the acetate spacer, repositioning your hoop and using your ruler as a guide to print your tesselated print. Remember to keep refilling your screen with paint as you work.

THE COMPLETE TESSELLATION.

Now that you have your finished tessellation pattern, you can see the contrast between the two screen printing methods. The hoop screen lends itself to a more handmade effect with slight imperfections or voids in places. If you wish to fill these in by touching up the prints with a fine paintbrush (as on page 66), you can do so but you may prefer a more rustic effect.

DRYING AND FIXING

When your pattern is complete, hang up your fabric to dry. Once it has dried completely you can fix your prints, following the instructions on page 20. You can then transform your fabric into cushion covers or a beach bag.

TAKING IT FURTHER

Tessellation repeats can be a really fun way to use a tiled design in a number of ways. If you wish to develop this idea further, why not try using contrasting colours?

Switching between a frame screen and a hoop screen can result in a multitude of different looks and variations – you may want to try making a two-layered, tiled design to create a shadow for a motif. This effect is known as 'offsetting' and is shown again in the beach blanket motif project, on page 90.

Rotating or changing the angle of your tiled prints will also transform a design. For example, try printing the sailing boat at a slightly slanted angle each time – it will make the boats look as if they are moving across the fabric.

Making a multilayered screen print may seem to be a more advanced technique, but if you prepare your layers correctly, it is a simple way to give more detail to a design.

Through the projects in this chapter, I will show you how to make and print a two-layer dragonfly design. As I work by the coast, I find that I get many visits from dragonflies in the courtyard of my studio. From the drawings I have made of the dragonflies, I have created two stencil templates (see pages 106–107) that can be lined up and printed one on top of the other.

Give yourself plenty of time in which to make the two stencils as they are heavily detailed – allow at least two hours per stencil. You may wish to make the stencils one day and print the following day.

As this is a more detailed design, I recommend that you use two, larger, metal frame screens – the frames I have used to print this project are 29.7 x 42cm (11¾ x 16½in). Using a metal screen without hinges is a great way to learn to be more hands-on and careful when positioning your prints.

You will need:

⚓ Two metal frame screens premounted with mesh, both 29.7 x 42cm (11¾ x 16½in)

⚓ Two sheets of tracing paper, no smaller than 29.7 x 42cm (11¾ x 16½in)

⚓ Two sheets of medium-weight white cartridge card, 29.7 x 42cm (11¾ x 16½in)

⚓ Dragonfly templates (see pages 106–107)

⚓ Cutting mat

⚓ HB pencil

⚓ Ruler

⚓ Craft knife

⚓ Masking tape

⚓ Smooth linen placemats, 48.5 x 33cm (19 x 13in) – I usually print four at a time

⚓ Teaspoon

⚓ Plastic palette knife

⚓ 100ml (3.5fl.oz) each of fabric paints in Parakeet (green) and Surf (blue) shades (Pick Pretty Paints)

⚓ Plastic squeegee

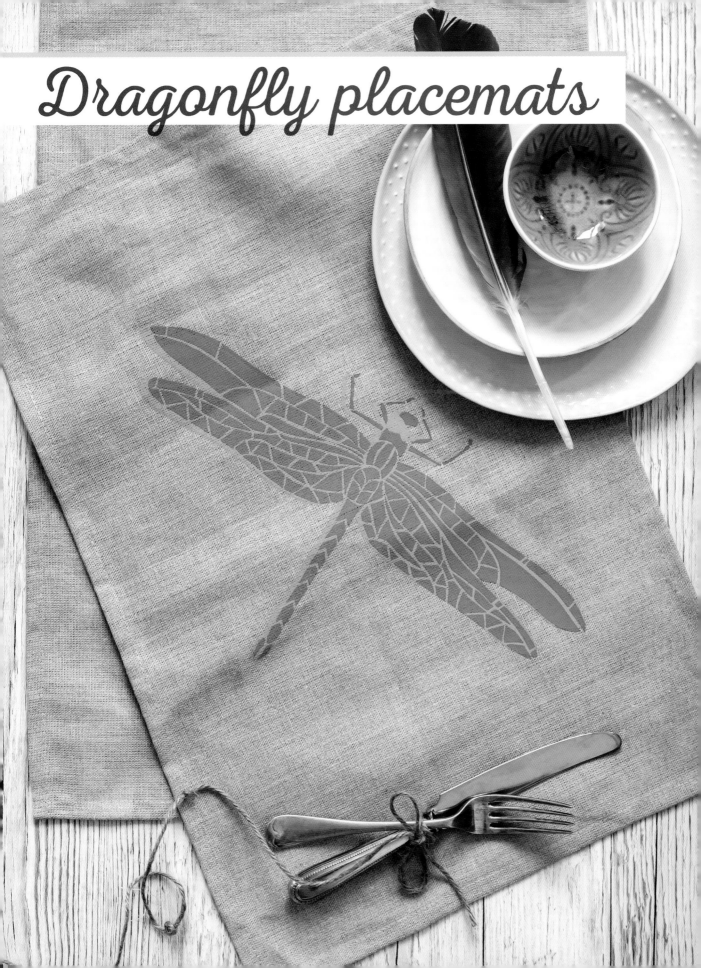

Dragonfly placemats

Making the stencils

1 With an HB pencil, trace the dragonfly outline template onto one sheet of tracing paper. Trace the detailed dragonfly template onto a separate sheet. As the dragonfly is a large design, tape down the tracing paper on top of the template to prevent the tracing paper moving.

2 Flip over the tracing of the outline. Lay the tracing paper on top of a sheet of white card and place the metal frame screen over the top of the card to ensure that the design will be central.

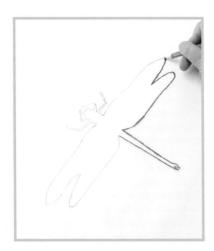

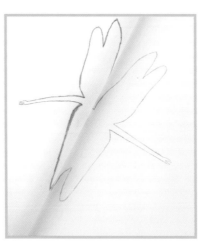

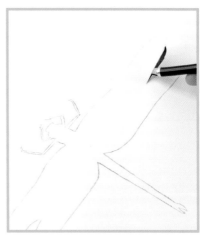

3 Move the frame aside. Transfer the dragonfly outline tracing onto the sheet of white card, ensuring again that the design is central on the card.

4 Lift the tracing paper to reveal the transferred design on the white card.

5 Cut out the outline stencil from the card with a craft knife. Cut out the small areas first to give yourself more control over the stencil and preventing it from slipping or becoming weak.

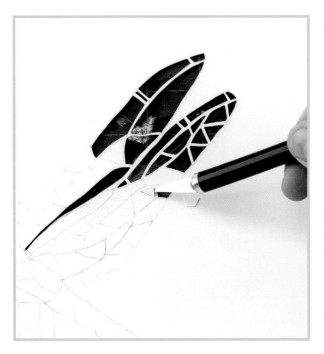

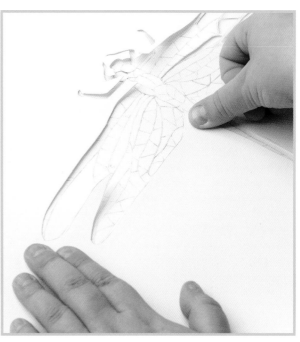

6 Transfer the detailed template from the tracing paper onto the white card in the same way as for the dragonfly outline, opposite. Cut out the details slowly and carefully. Work from the outside details inwards – this will help prevent the stencil from breaking due to the delicate detail in the wings.

7 When you have cut out both templates, place the outline template on top of the detailed template to ensure that your prints will line up.

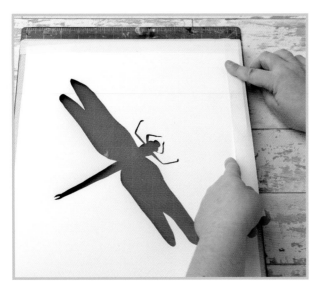

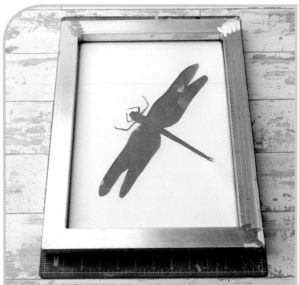

8 Position the outline stencil on the back of one metal frame screen and secure it tightly with masking tape along all four edges to ensure the stencil will not come loose.

This outline stencil will form the base of the dragonfly print. The detailed stencil will form the intricate top layer.

Printing the base layer

This is a similar process to printing the swallows on pages 42–45 – preparation is key as you will not be able to see through the screen to reposition it once there is paint on the screen.

Smaller fabric items such as placemats can be more temperamental than larger pieces of fabric, as they can slide out of place – I recommend securing the placemats to your worksurface with masking tape before you begin to print.

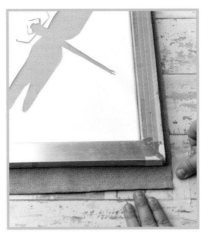

1 Place the first placemat on your worksurface and lay the frame on top. Use masking tape to tape around the four corners of the mat – this will help you to keep the placement of your prints consistent.

2 Use masking tape to mark where on the placemat the top and bottom edges of the frame screen sit.

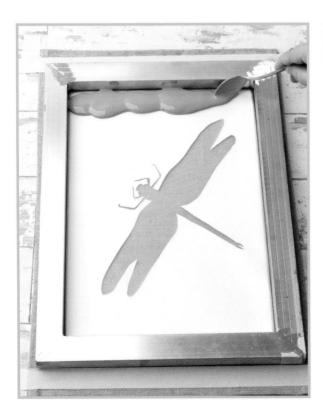

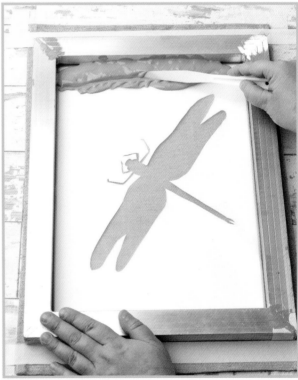

3 Once your markers are in place and secure, use a teaspoon to spoon out the paint onto the screen above the design, Here, I am using Parakeet (green) fabric paint.

4 Spread out the paint using a plastic palette knife – you may find you have a lot of excess paint at the sides of your screen; use the knife to keep the coverage even.

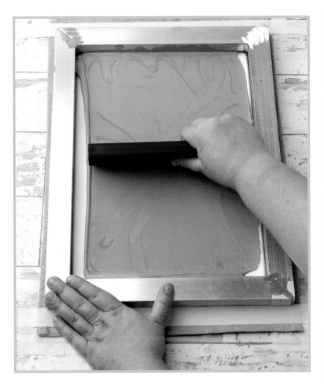

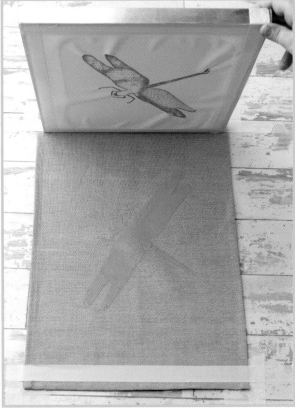

5 As you are using a mesh screen, use a plastic squeegee to pull down the paint. The plastic squeegee will give you more flexibility and allow you to change pressure more easily than a wooden-handled squeegee. Pull your paint through the screen, keeping the squeegee at a 45-degree angle to the screen surface. Return the squeegee to the top of the screen and repeat the process to pull any excess paint through the screen.

6 Lift the frame from bottom to top to reveal your print – lift it slowly to prevent the fabric from smudging. Remove your placemat and leave it to dry completely before you apply the second layer – the placemats I have used are lightweight and will normally dry between 15–25 minutes. In the meantime, you can print the base layer onto a second placemat.

Tip

Make sure that after every print you check the screen surface and the frame to make sure no paint is being transferred. If you do find paint on your frame, wipe it off with a wet wipe (baby wipe), a rag or paper tissue and tape over that area for peace of mind when making your next print.

7 Use your taped markers to determine where to position your next placemat, for the second base print. Repeat steps 3 to 6 until you have printed the base layer on all of your placemats.

Printing the second layer

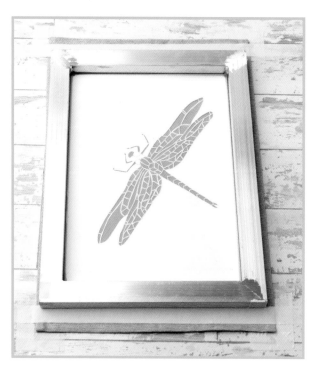

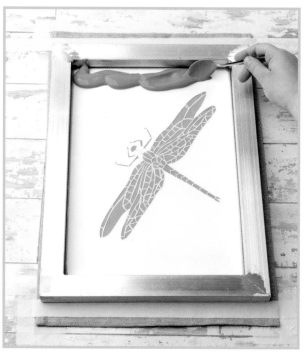

1 Position the first placemat you printed (completed at step 6, page 77) back within the markers. Replace the outline stencil on the frame with the detailed template (or attach the detailed stencil to a second, separate metal frame with mesh screen). Repeat step 2 on page 76 to secure the frame on the placemat.

2 Spoon paint in a contrasting colour – here, Surf (blue) – onto the screen.

Tip

If your second stencil is slightly misaligned on the placemat on top of the base layer, use a ruler and a pencil to mark out the sides of the screen on the masking tape markers for added accuracy. Adjustments sometimes need to be made to your positioning, regardless of how many times you print a multilayered screen print.

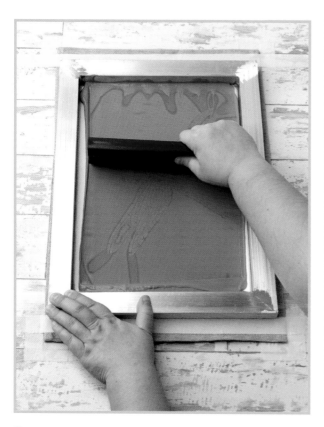

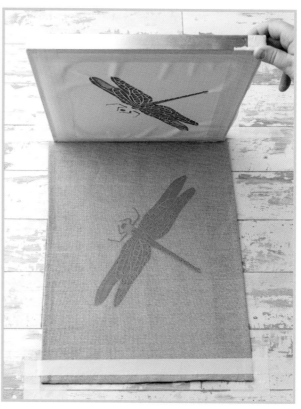

3 Pull the paint down, and through, the screen using the plastic squeegee. Hold the squeegee at a 45-degree angle to the screen.

4 As the second print layer is more detailed, lift up your screen gently to prevent the stencil sticking to the paint or ripping. Remove the placemat from your worksurface, and repeat steps 1 to 4 on this and the preceding page to print the second, detailed layer on all of your remaining placemats.

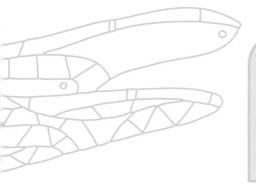

CLEAR-DOWN, DRYING AND FIXING

When you have printed both layers of your placemats, leave them to dry completely. You may wish to fix your prints before you use the placemats – refer to page 20 for the best methods for doing this.

Leave your screen to soak in warm, soapy water. This will make it much easier to remove the stencil from the mesh if you do not want to reuse the design.

Dragonfly table runner

THE PRINTED TABLE RUNNER IN USE.

If you want to take the dragonfly design even further, why not position the motif in the corners of fabric napkins or even in the corners of a large tablecloth?

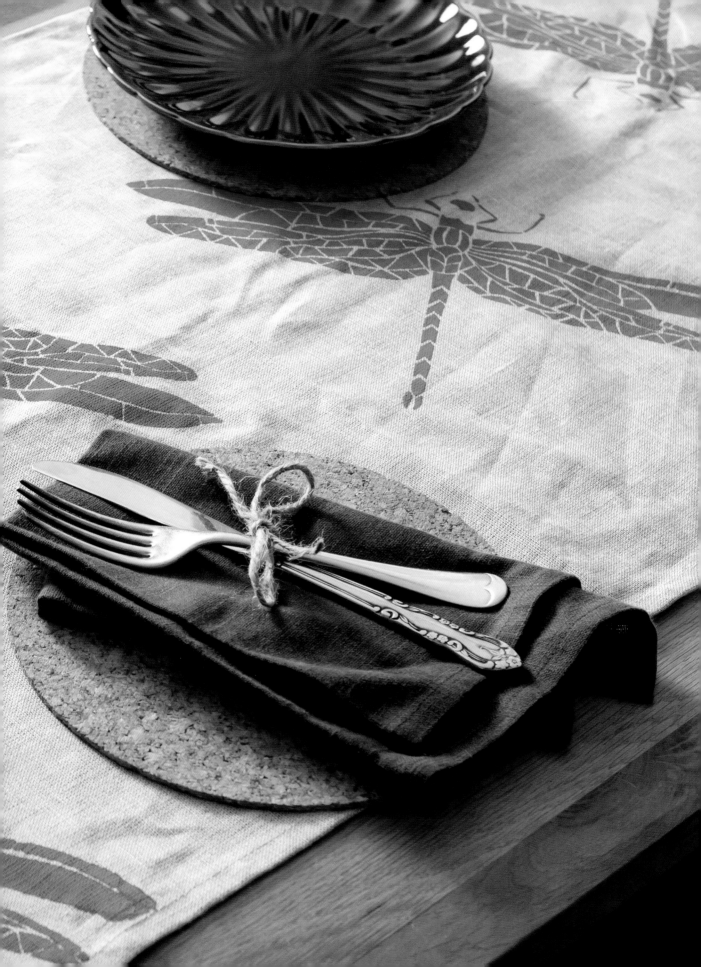

To take your multilayered dragonfly design one step further, print this table runner to complete a collection of bespoke table adornments. Reuse the detailed stencil from the placemat project to print the corresponding table runner but be sure to wash your screen well before applying new paint colours.

You will need:

- ⚓ One metal frame screen premounted with mesh, 29.7 x 42cm (11¾ x 16½in) and detailed dragonfly stencil (see page 106)
- ⚓ Masking tape
- ⚓ Smooth linen table runner, 48 x 135cm (19 x 53in)
- ⚓ Teaspoon
- ⚓ Plastic palette knife
- ⚓ 100ml (3.5fl.oz) blue fabric paint – I have used the Surf shade
- ⚓ Plastic squeegee

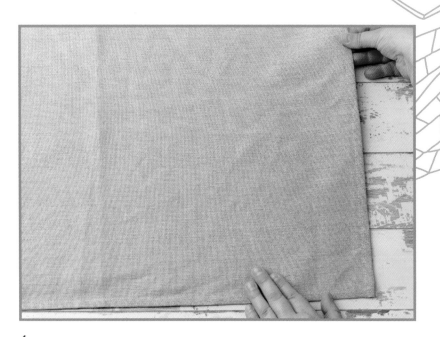

1 Lay down the table runner on your workspace. If you have previously printed the placemats, make sure you remove all masking tape markers first.

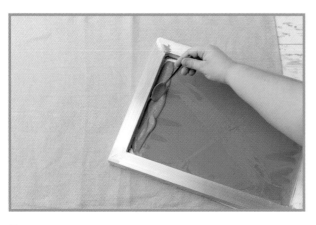

2 Working freehand, position your screen diagonally in the bottom-right corner of the fabric runner. Top up the paint on the screen with a teaspoon.

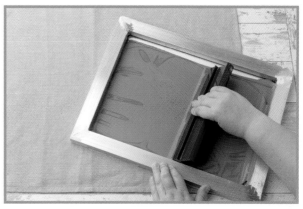

3 Pull down the paint over the screen using the plastic squeegee – hold the squeegee at 45 degrees to the screen.

Tip

Printing on a diagonal will allow you to place the screen back down in the opposite direction to repeat the design without getting any paint back on the screen by accident.

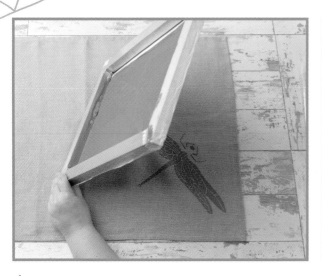

4 Lift your screen from bottom to top to reveal your first print.

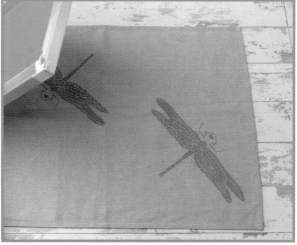

5 Rotate the frame 180 degrees and print your second dragonfly facing the opposite direction to the first.

Continue to print the dragonflies in this formation until you reach the other end of the fabric. Dry the fabric runner completely, then fix the print to the fabric following the instructions on page 20.

Placement motifs can add charm to a plain fabric item that you have had for years. In this project, I will show you how to decorate fabric that can be simply transformed into a beach blanket.

You will be working with larger embroidery hoops than before, exposing the designs and printing two layers in the same place on the fabric. This is an advanced way of adding detail to your print surface.

This two-layered shell design is inspired by one of the many shells I have collected from the Cornish shoreline and painted in watercolour.

You will need:

⚓ Shell templates (see page 108)

⚓ Two 20cm (8in) bamboo embroidery hoops

⚓ Habotai silk or silk scarf (alternatively any silk left over from previous printing projects)

⚓ Scissors

⚓ Red felt-tip pen

⚓ Ruler

⚓ Large, natural, medium-weight fabric blanket suitable for outdoor use

⚓ Masking tape

⚓ 100ml (3.5fl.oz) of each fabric paint in Wheat and Cinnamon shades (Pick Pretty Paints)

⚓ 118ml (4fl.oz) matt heat-resistant varnish

⚓ Selection of fine watercolour paintbrushes

⚓ Black ballpoint pen

⚓ Two teaspoons, one for each paint colour

⚓ Wide sponge dabbers

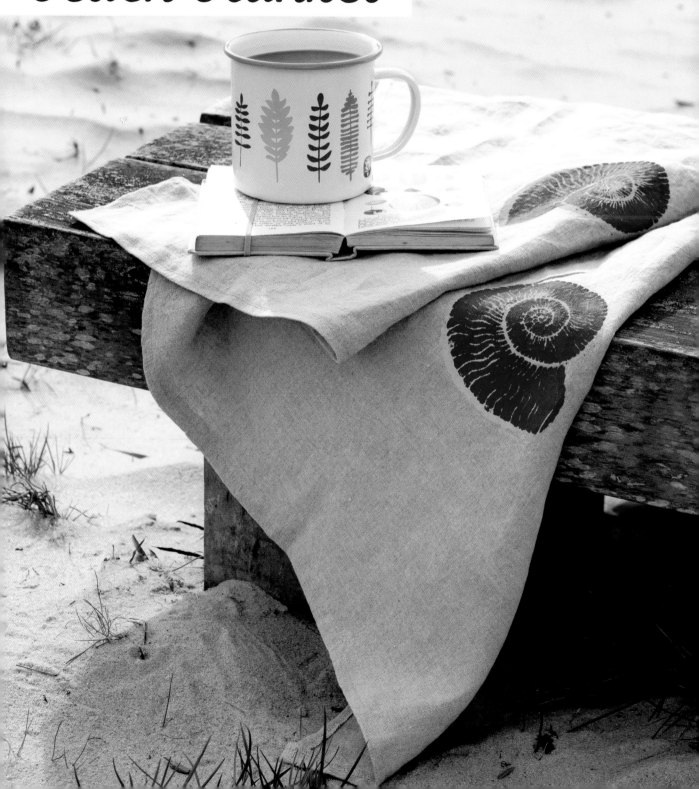

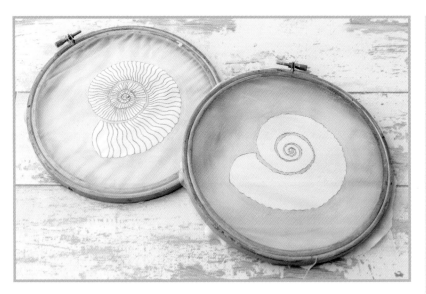

Tips

As you transfer the shell designs onto the hoop screens, position your hoop on your worksurface so that the screw fixing is at the top of the hoop, and the shell is positioned centrally and consistently within the screen area.

Allow plenty of time for making up these hoops as the amount of detail involved in the designs means they will take longer to make up than the embroidery hoop screens in previous projects.

1 Create your two embroidery hoop screens following the instructions on pages 22–23, keeping in mind that you will need more silk to cover these larger screens. Make sure your silk screens are tight and smooth – like a drum head. Follow the instructions on pages 28–29 to transfer the shell designs from page 108 onto the individual screens and expose the designs.

2 Place one hoop screen on top of the other to ensure that the shell designs are in the same position on both screens.

3 With your ruler and a red felt-tip pen, make four marks on the edge of one of the hoops – imagine a compass, and mark North, South, East and West.

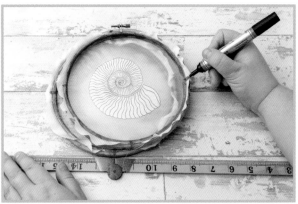

4 Place the marked hoop with the base flush against a ruler, the screw fixing at the top (at North).

5 Lay the second hoop on top, matching the positions of the screw fixings, and make four identical red-pen marks on the second hoop to match the first. This will help you to line up your two print layers.

Printing the base layer

Print the base layer of the shell motif in one corner of your beach blanket at a time.

1 Fold your blanket into quarters so that you can focus on the corner into which you will be printing. With masking tape, mark out the bottom-right corner of the blanket as a reference point.

2 Place your ruler under the bottom edge of the blanket and use it as a guide to position your first hoop flush against the bottom edge and the right-hand edge of the blanket. This should be the less detailed motif as this will form the base layer to your print.

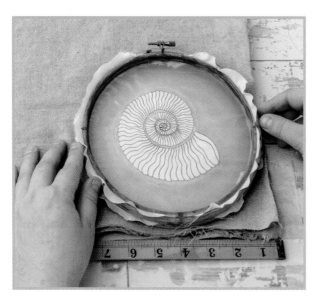

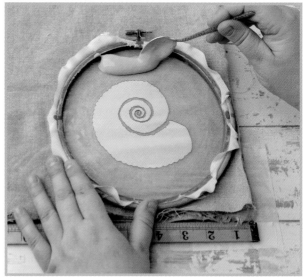

3 Place the second, more complex, design on top to double-check that the prints will line up. As the hoop is 20cm (8in) wide, you can also ensure that the hoops will line up centrally by positioning the 'south' marks in line with the 10cm (4in) mark on your ruler.

Put the second (complex) screen design aside until step 1 on page 89.

4 Use a teaspoon to spoon paint onto the first screen at the top of the hoop – here, I am using a Wheat colour.

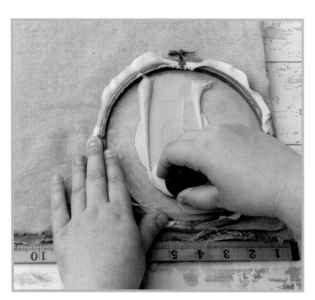

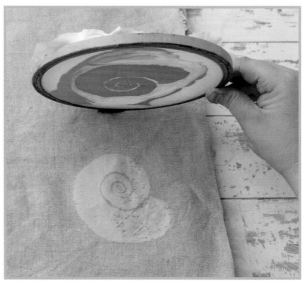

5 Hold a sponge at its base and pull the paint through the screen over the top of the shell design. Keep the sponge at a 45-degree angle to the screen.

6 Lift the hoop from the fabric – from bottom to top – to reveal the base print. Move the hoop away from the printing area to avoid any excess paint accidentally transferring to the fabric. Rotate the blanket 90 degrees to position the next corner against the tape markers, ready to print. Repeat steps 3–6 to print the base layer on all four corners of the blanket.

Printing the second layer

Leave the blanket to dry while you prepare the second print layer. Return the blanket to the first position as shown in step 2 on page 87, using the masking tape markers and your ruler to help you position the second hoop in the corner of the blanket.

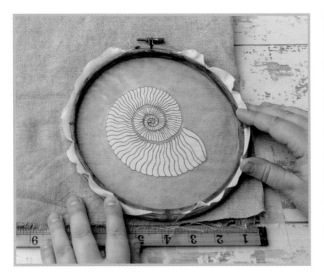

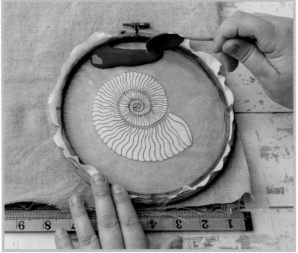

1 Once the base motifs are dry, fold your blanket in quarters again and position the blanket so that the first base motif (completed at step 6, page 88) is in its original position on the bottom-right of the blanket. Use the tape markers and your ruler to reposition the blanket, and lay the second – more complex – hoop screen directly on top of the first print.

2 Use a teaspoon to apply a new paint colour. As this is the top print and the paint is a darker colour, make sure you don't overfill the screen with paint – refer to any test prints you may have done before. A light application of pressure when pulling the paint through at step 3 will hopefully stop the details from flooding or bleeding.

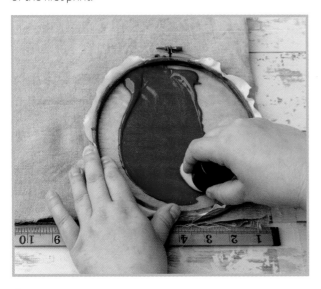

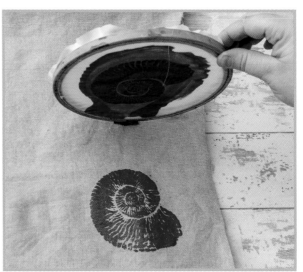

3 Pull down the paint over the shell design using a sponge. Apply less pressure than for the base motif as you do not want the finer details of the design to bleed.

4 Lift up your hoop from bottom to top to reveal your two-layer placement motif. Allow the print to dry, then rotate the blanket, and repeat steps 1–4 on the other three corners of your blanket.

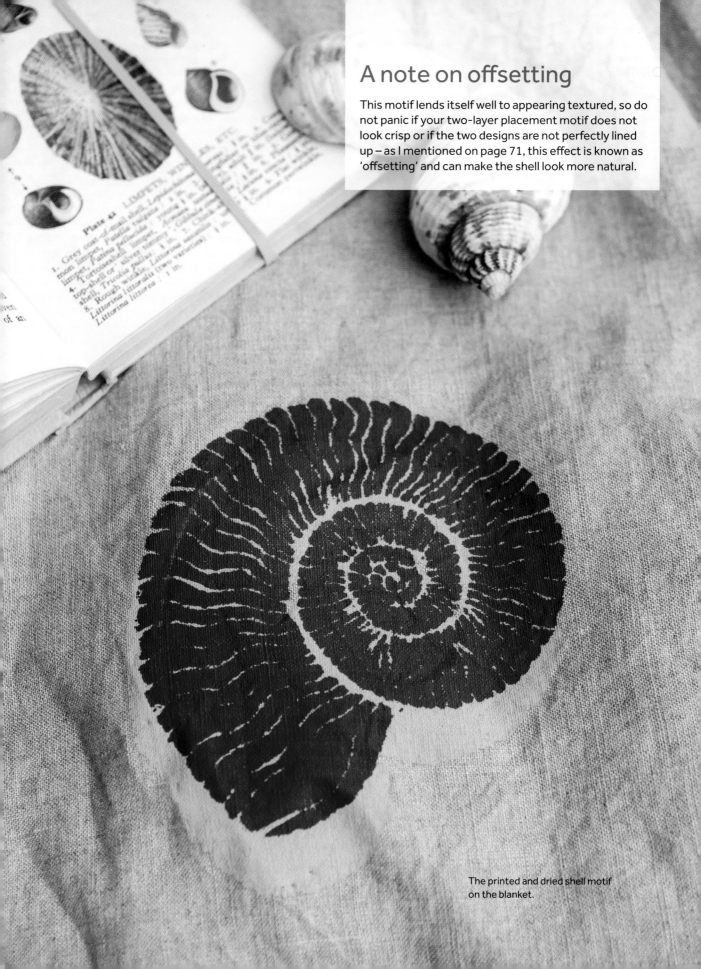

A note on offsetting

This motif lends itself well to appearing textured, so do not panic if your two-layer placement motif does not look crisp or if the two designs are not perfectly lined up – as I mentioned on page 71, this effect is known as 'offsetting' and can make the shell look more natural.

The printed and dried shell motif on the blanket.

DRYING AND FIXING

Leave the blanket to dry completely before fixing the prints (see page 20) and using the blanket.

> ### TAKING IT FURTHER
>
> A large two-layered hoop design can really give a pattern depth. If this is an effect you wish to experiment with further, have a look at how you can create your own artwork and designs (see pages 98–101). Prints of different-shaped shells, animals and floral patterns can be achieved using multiple hoop layers.
>
> A simple shell design can be transformed in many ways using the paint to create gradient effects. Gradient effects come about when you take two or more colours and fade them or mix them in various directions on the hoop screen.

Gradient variations

Below are two examples of different variations of the same shell design, printing two layers with three paint colours: Wheat, Blackberry and Cinnamon.

One layer is printed simply, using one colour; the second layer is a half-and-half gradient, which is created by pulling two colours down the screen over an exposed design, at the same time.

I hope that these simple examples give you an insight into the blends and contrasts you can make by separating out your printing layers and printing a design using more than two paint colours.

Gradient prints are explained in more detail in the next and final project in this book, overleaf.

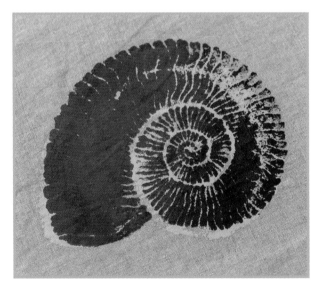

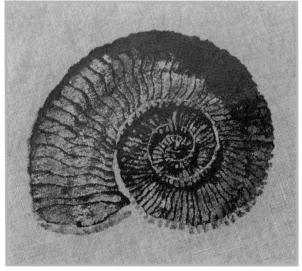

The base print of this design is the colour Wheat printed as a solid colour. The top print is a half-and-half gradient, where two colours, Cinnamon and Blackberry, have been pulled down the hoop screen.

The base print here is a half-and-half gradient of Cinnamon and Blackberry, pulled from the top to bottom of the hoop screen. The top print is a light layer of Wheat.

Gradients, like the shell variation prints on page 91, can be made in many ways: from changing the tone of your paint colour from light to dark to mixing colour shades or merging them to create a marbled effect.

As most of the projects have involved printing blocks of colour, I thought this would be a nice variation to finish with – a project featuring colour gradients. The merging and fading of the colours reminds me of the ever-shifting colours of the shoreline.

This project uses a simple pebble and seaweed design template and four paint colours applied in an alternating gradient formation for a faded, rippled effect.

You will need:

- ⚓ Pebble and seaweed design templates (see page 110)
- ⚓ Sheet of tracing paper, 29.7 x 42cm (11¾ x 16½in)
- ⚓ Several sheets of cartridge paper, 29.7 x 42cm (11¾ x 16½in) – I have used a spiral-bound pad of cartridge paper
- ⚓ Scissors (to trim away the cartridge paper perforations)
- ⚓ Pencil
- ⚓ Cutting mat

- ⚓ Craft knife
- ⚓ Masking tape
- ⚓ Metal frame screen, 29.7 x 42cm (11¾ x 16½in) – premounted with mesh
- ⚓ 100ml (3.5fl.oz) each of water-based printing paints in Nordic blue, Mist, Pebble and Sage shades (Pick Pretty Paints)
- ⚓ Four teaspoons, one for each paint colour
- ⚓ Plastic palette knife
- ⚓ Plastic squeegee

OPPOSITE, THE PEBBLE GRADIENT PRINT.
If you print your pebble gradient print onto a sheet of cartridge paper from a spiral-bound pad, trim off the perforated edge before hanging or framing your print.

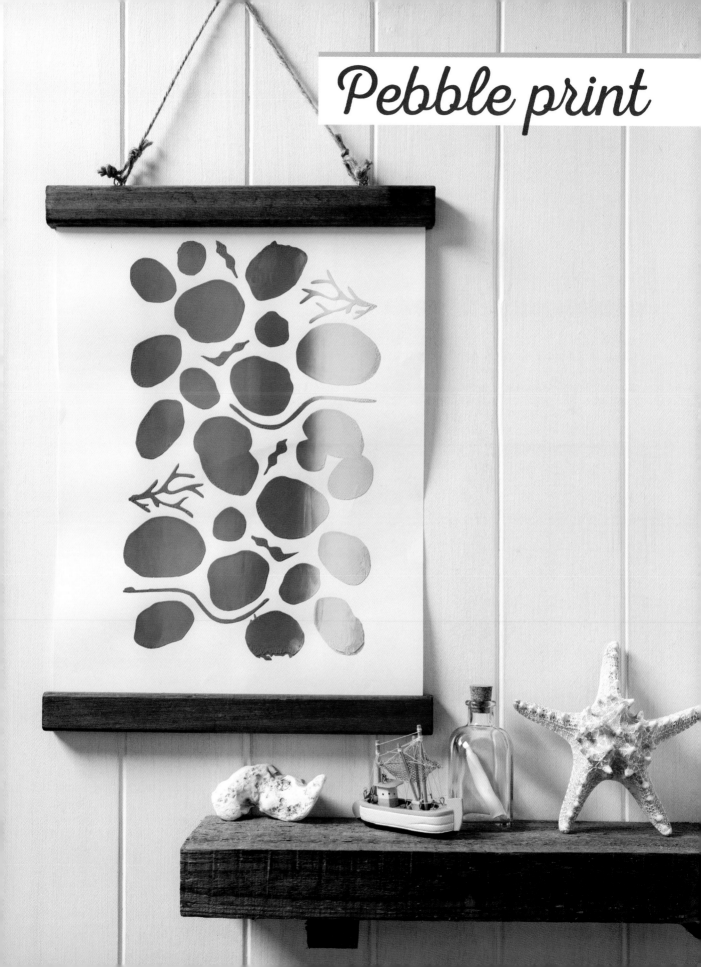

Pebble print

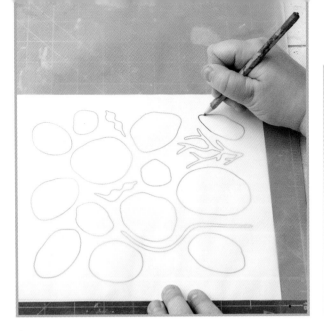

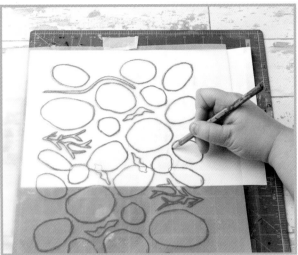

1 Trace the pebble design from page 110 onto one half of a sheet of tracing paper, in pencil.

2 Rotate the template and the sheet of tracing paper and repeat the tracing on the empty half of the tracing paper. Overlap any of the shapes as you trace them – this can make the design look more natural.

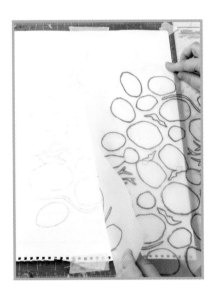

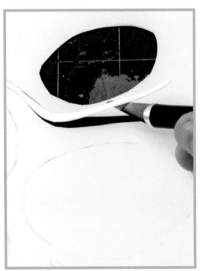

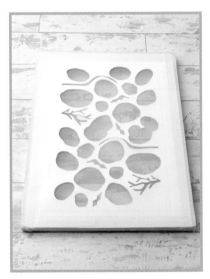

3 Transfer the whole design onto a sheet of cartridge paper.

4 Cut out the shapes using a craft knife. Work from the top of the sheet downwards, and take your time – start with the smaller details. Rotate the card if you need to, to prevent the stencils tearing.

5 With your trusty masking tape, attach the stencil to the metal frame screen in the same way as for the dragonfly print project, on page 75. Turn over your metal frame screen, ready to print onto a fresh sheet of cartridge paper.

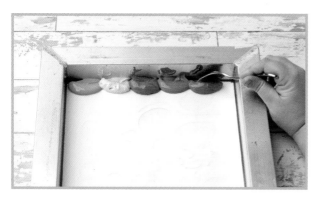

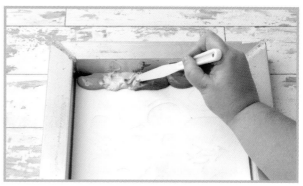

6 Decant a 5cm-(2in-) wide pool of each colour paint along the top of the frame – use a different spoon for each colour. The colours shown above are, from left to right: Nordic Blue, Mist, Pebble, Sage and Pebble again.

7 Blend the colours gently together with a plastic palette knife.

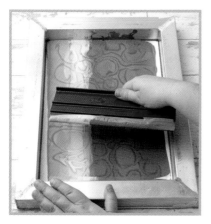

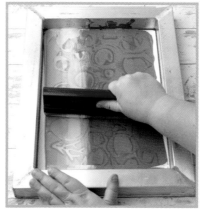

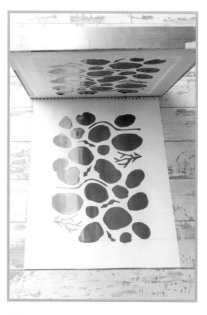

8 Using a large plastic squeegee, pull down the colour through the screen in one motion. When you reach the bottom of the frame, try to capture any excess paint on the squeegee.

9 Take your squeegee back to the top and pull another time.

10 Lift up your screen from bottom to top to reveal your gradient print.

TAKING IT FURTHER

If you have spare cartridge paper, make more gradient prints until your paint runs out. You will find that each print will vary as the paint spreads, merges and blends, making an interesting, limited-edition series of prints.

INSPIRATION AND IDEAS

Inspiration for your own screen printing designs does not have to come from a complex source or a detailed plan. The majority of my ideas start from small moments of visual interest, or eye-catching patterns I come across on coastal walks, alongside hedgerows or when I'm beach-combing.

Take a sketchbook or a camera out and about, and you will find yourself instinctively capturing shapes, moments and objects that you see along the way. I like to look at the outlines of natural objects and see what details can be spotted on their surfaces – from the 'window panes' on a dragonfly's wing to the variety of markings on a seashell. You never know where your ideas will lead you.

In this final chapter of the book, I will show you how you can turn your visual ideas, sketches and images into prints. You can begin to experiment with tracing and redrawing shapes, even cutting them up and re-placing them on the page, all to inspire you and provide you with a variety of choices for your print designs.

Creating your own designs

Creating your own artwork and transforming it into a print is a great way to convert and preserve a memory and develop your own designs. Your artwork can be inspired by different visuals around you – from certain objects, your surrounding area, or even photographs.

These simple steps will show you how to transform your own drawings into a design that is ready for screen printing.

1 Trace the silhouettes

Silhouettes, which make effective screen printing designs (such as feathers or swallows) can be simply created by tracing your artwork from a sketchbook. On a sheet of tracing paper, draw around your chosen motif in pencil. You may wish to concentrate on just the outline with a view to printing a single layer or a pattern repeat.

You may also wish to trace silhouettes and outlines at different scales – these can be transformed into interesting border patterns or even simply one-off prints.

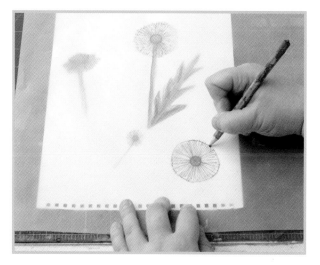

1 Trace the outlines of your drawings to transform into silhouette prints.

2 Vary the scales and sizes of your outlines.

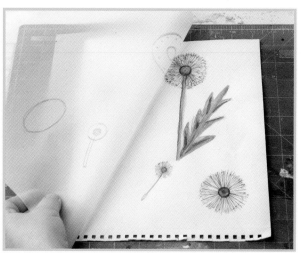

Three variations on a design theme.

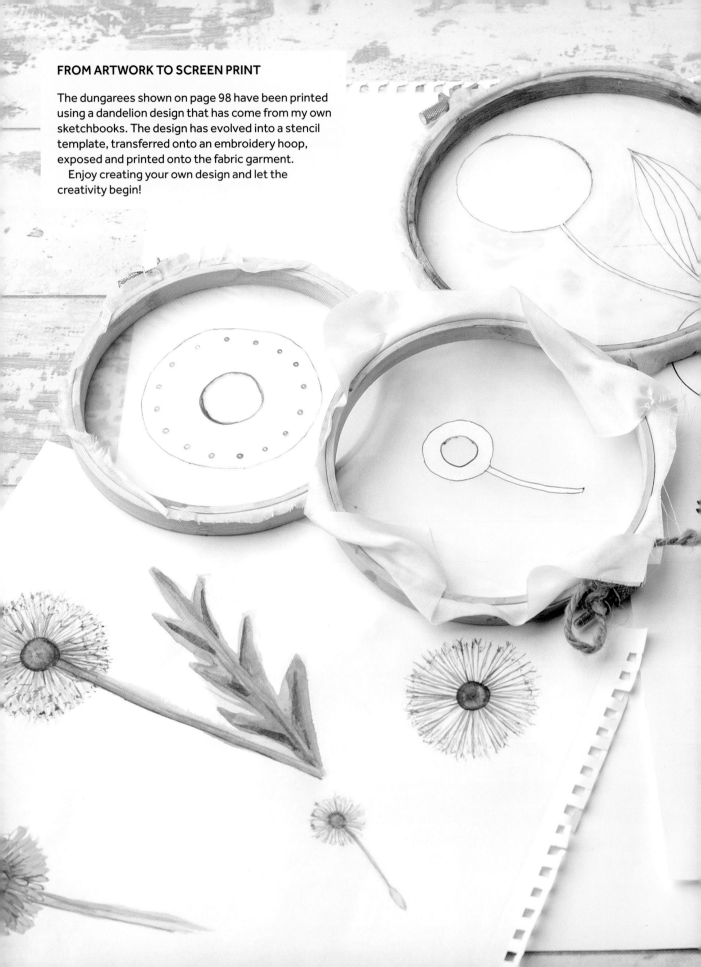

FROM ARTWORK TO SCREEN PRINT

The dungarees shown on page 98 have been printed using a dandelion design that has come from my own sketchbooks. The design has evolved into a stencil template, transferred onto an embroidery hoop, exposed and printed onto the fabric garment.

Enjoy creating your own design and let the creativity begin!

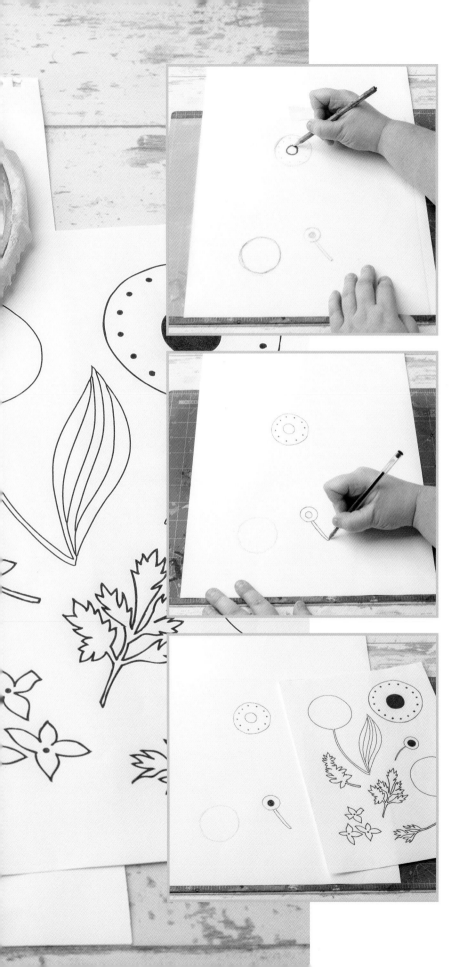

2 Block out details

Place your tracing paper on a sheet of card or paper. Transfer the silhouettes by rubbing over the outlines in pencil. In addition, block out a few design details for interest. This will transform your original silhouettes into more graphic designs.

3 Reinforce the shapes

You can use black pens or black ink with fine paintbrushes to pick out the lines or patterns you see in the objects. You will start to see a design template evolve. Try repeating, rotating or cutting up the motifs to create new, interesting designs.

4 Make the design template

When you are happy with your graphic motifs, trace and transfer the designs onto a fresh sheet of paper. You can now transfer your own designs onto a hoop silk screen or metal frame screen to be printed or exposed, following the instructions earlier in the book.

Leaf templates for pages 28–37.

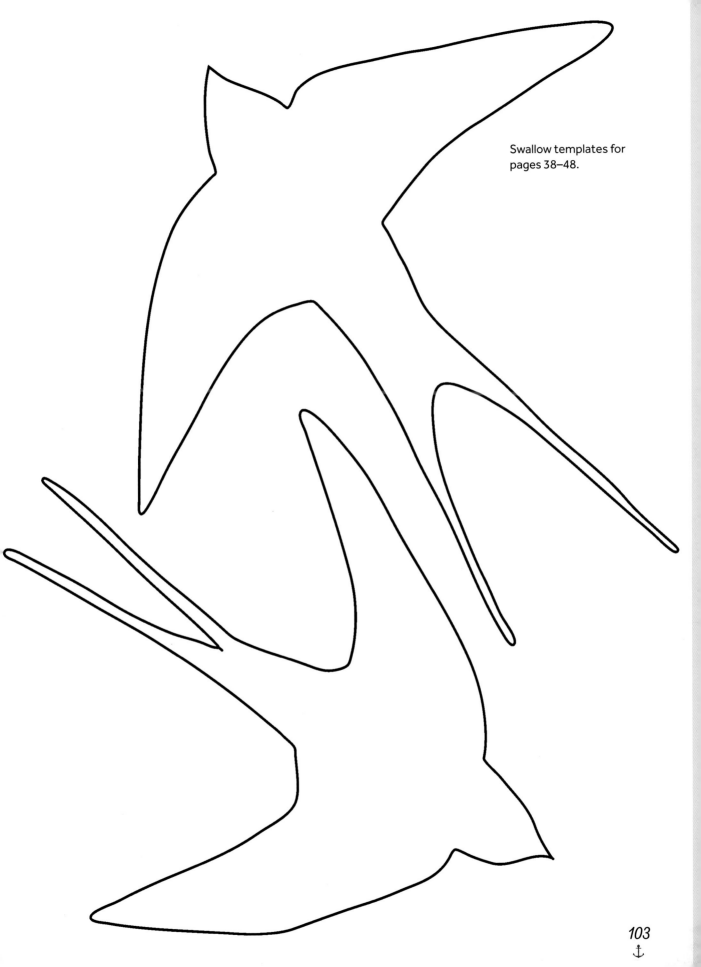

Swallow templates for pages 38–48.

Feather templates for pages 50–61.

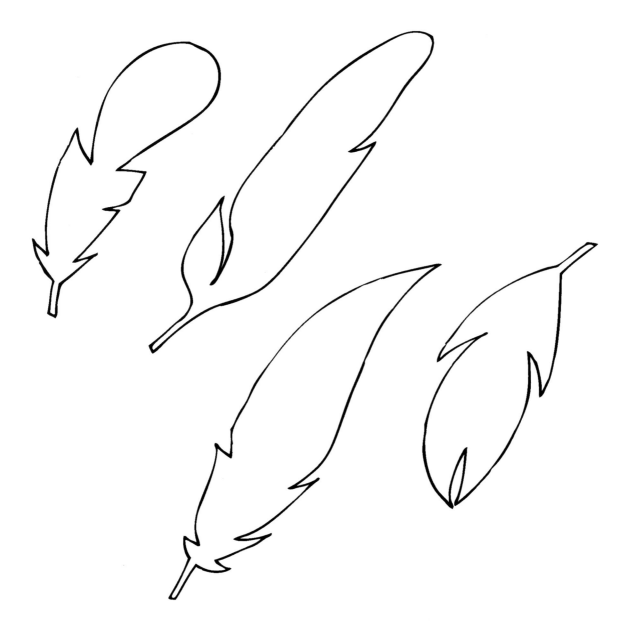

Sailing boat and anchor templates for pages 62–71.

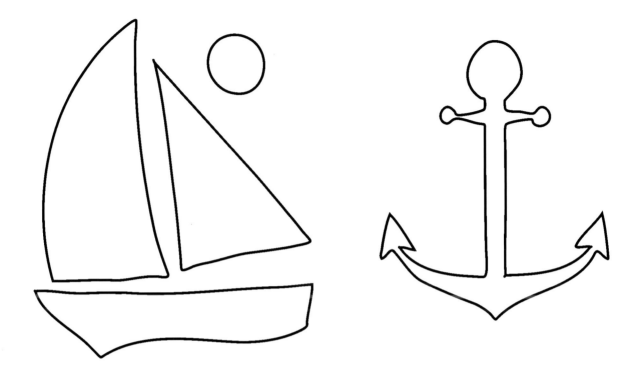

Additional sailing boat and starfish motifs
for you to use for your own prints.

Dragonfly templates for pages 72–83.

These templates are reproduced at 90% of their
original size. To reproduce the templates at full size,
photocopy them at 111%.

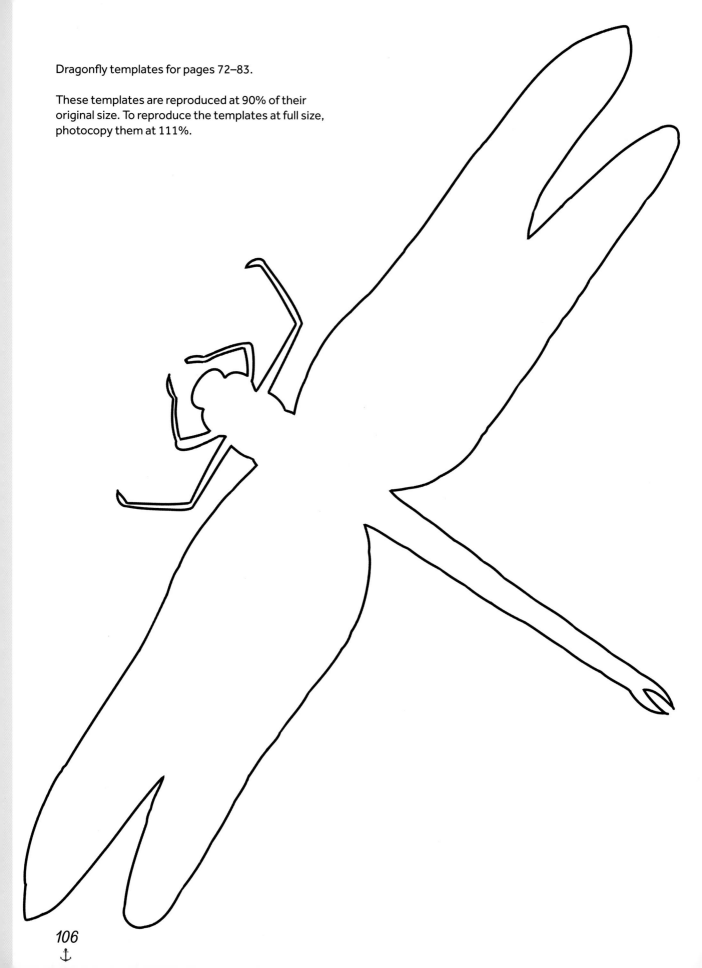

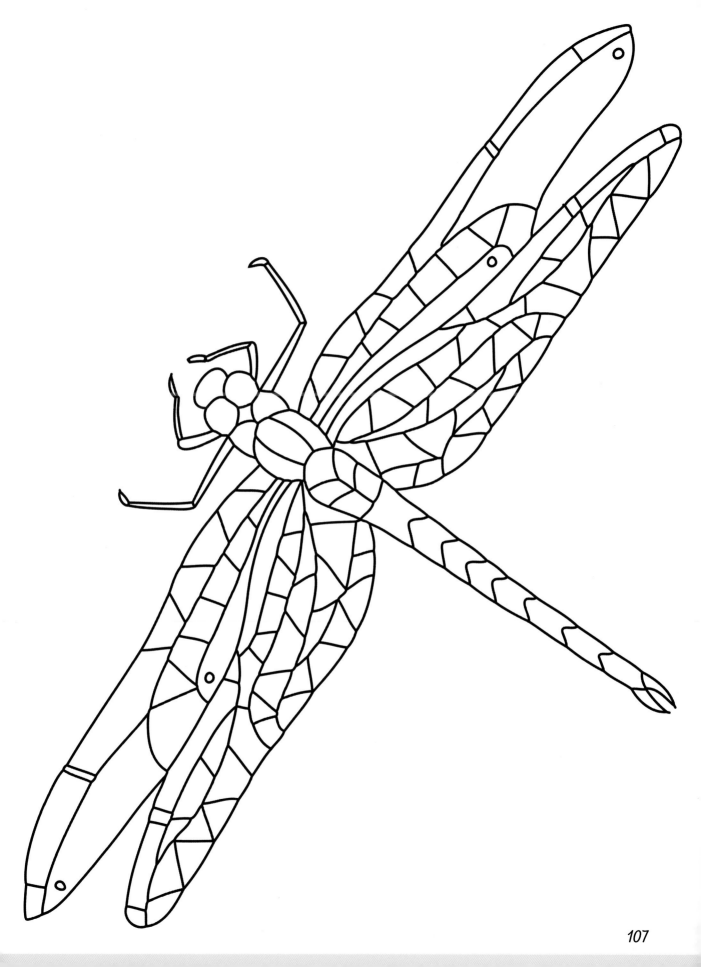

Additional shell templates for pages 84–91.

Additional seaweed template
for your own use.

Pebble and seaweed templates for pages 92–95.

Binder

A medium that binds and mixes pigments and their properties together (see page 20).

Exposing

A technique used to fix designs onto a screen for repeated or sustained use (see pages 28–29).

Fixing

A process that uses heat or steam to secure a printed design to the fabric surface (see page 20).

Half-drop

A repeat print formation in which the designs appear to 'drop' down the fabric in a diagonal pattern (see pages 50–57).

Hinge

A mechanical bearing attached to a frame screen that connects the block frame to the frame screen and allows the frame to be lifted or moved (see page 40).

Hinge rest

A prop attached to the screen that supports the frame when lifted away from the printed item (see page 40).

Inks

A common term used to describe printing colours and paints (see page 12).

Marker

A reference point to aid measurement or lining up of frames or other equipment.

Mask out

To block off an area of a print surface that you do not want to print on.

Pigment

The colour component that makes up a shade of printing paint.

Production run

A series of printed items made from the same design in a consistent, repetitive process (see pages 38–48).

Pull-down

The action of a screen printer using a squeegee to pull paint down the surface of a screen.

Reference

A fixed point or stage of assessment – such as a positional guide for a production run.

Shrinkage

A decrease in size or scale (see page 19).

Shrink percentage

A calculation of the decrease in scale – such as when fabric is washed (see page 19).

Silhouette

The filled outline of an object or shape.

Spacer

A measured object that helps you calculate how much space to leave between prints – such as in a tessellation (see page 65).

Stencil

A cut-out design on paper, card or acetate through which paint can be pulled on a screen.

Template guide

A printed reference of a design motif to help you work out where to position your next print (see page 53).

Tessellation

A tiled, repeat pattern of shaped, and alternate, printed designs (see pages 62–71).

Test print

The first printed attempt at pulling paint through a screen.

Tile

A simple design that can be repeated a number of times in a neat formation.

Transferring

The movement of a design or print from one surface to another.

INDEX